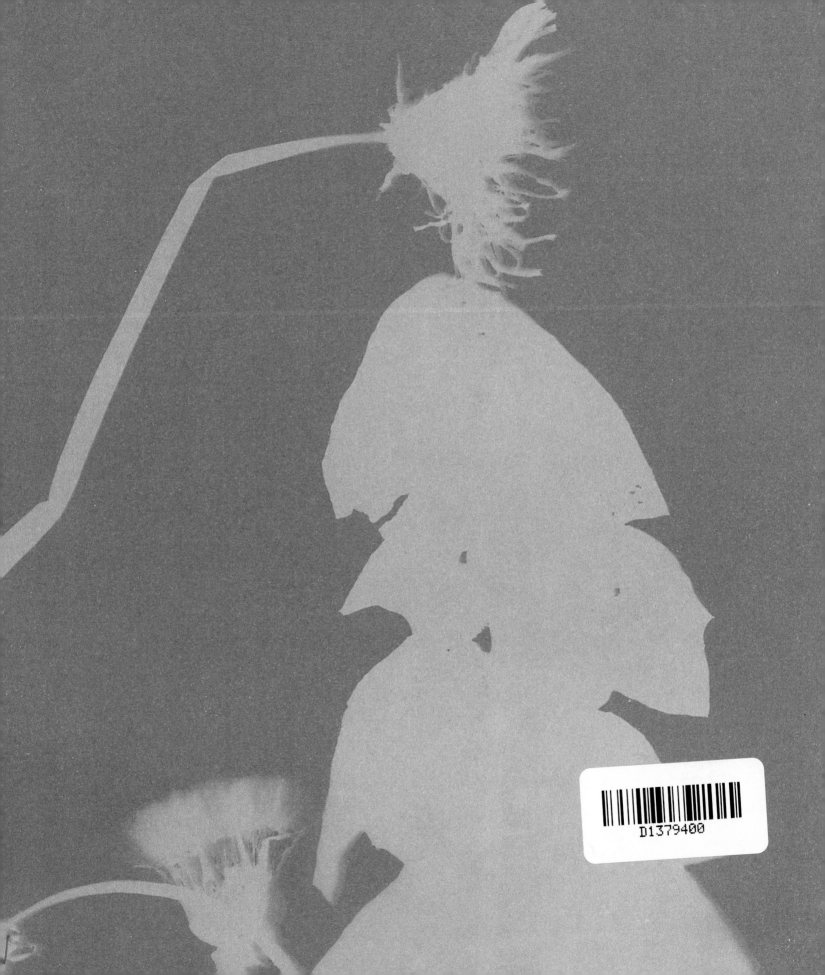

Things

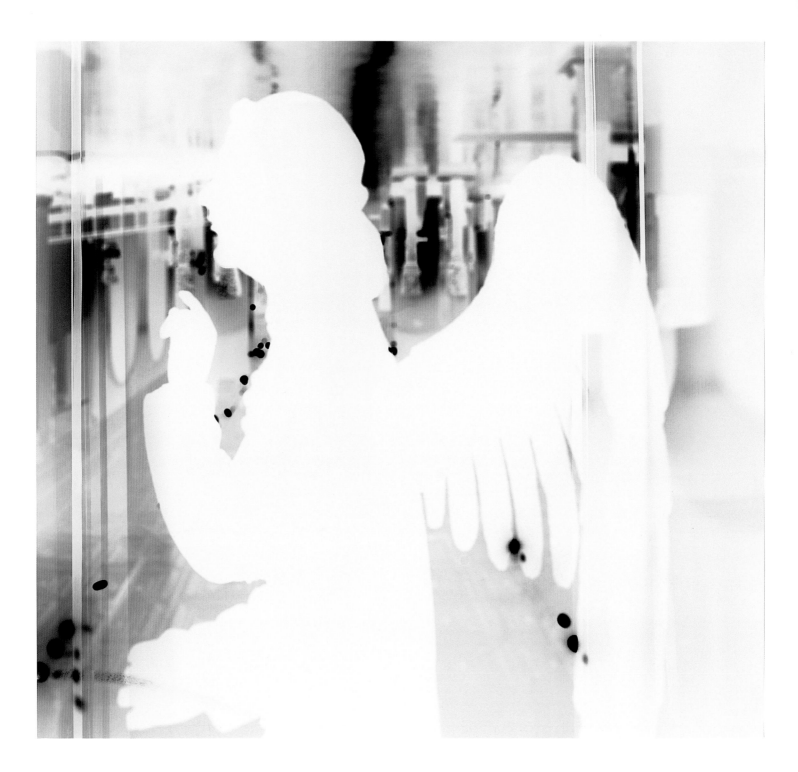

Edgar Lissel
German, born 1965

Angel of the Annunciation, 2002
Gelatin-silver print
96 x 103 cm

Things

A Spectrum of Photography
1850–2001

Edited by Mark Haworth-Booth
Introduction by Marina Warner

in association with the

Jonathan Cape, London Victoria and Albert Museum

facing title page

This photograph was made in the V&A using a giant pinhole camera, or camera obscura, built around a display case in Gallery 24 that contains a 15th-century carved oak angel.

Photographic paper was attached to the back of the case and a unique negative image was formed by ambient light filtering onto the paper through a pinhole. The exposure lasted 24 hours. The elegant silhouette of the sculpture inhabits the inverted image of the gallery, which is transformed into a celestial realm where points of light appear like black stars.

Although he has practised extensively in Germany this was Lissel's first project with a UK museum. The V&A commissioned him to create this photograph during a two-week residency to coincide with the Canon Photography Gallery exhibition *Seeing Things: Photographing Objects 1850–2001*.

facing introduction

Ludwig Belitski
German, 1830–1902

Venetian-style glass (probably German, 17th and early 18th century)
Salted paper print from glass negative
published in *Models for Craftsmen*, vol. II, 1855
by the Minutolisches Institut, Liegnitz, Silesia
23 x 18.3 cm

Given by Prince Albert, 1855

Contents

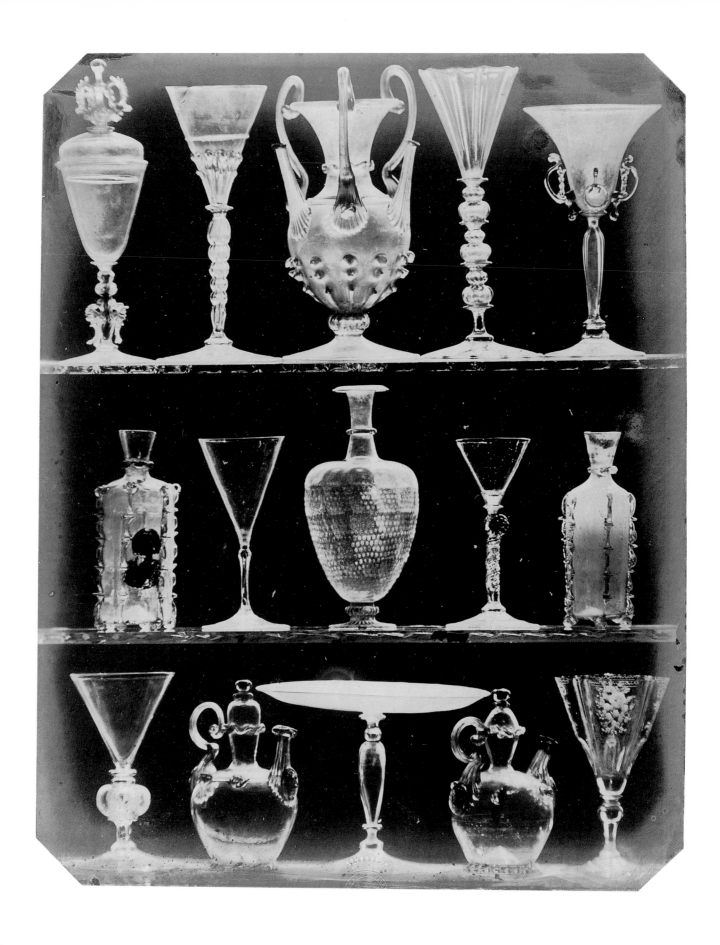

Introduction
Marina Warner

In Russian there is a word for 'thing' with no precise equivalent in English: 'vesch' means 'a thing with a soul' and it comprises mementoes of course, but expands far beyond that category. It describes any thing that resonates and possesses vitality and significance and has become imbued by human attachment with presence and feeling.[1] Since its invention, photography has become the principal means of working the enchanting transformation when a mere object becomes a thing with a soul.

Victorian portrait photographs were often keepsakes, love tokens and mourning images, set in lockets and framed in velvet and gold or the loved one's hair, with clasps to intensify their intimacy. But tenderness and connection, which photographs inspired then and still do, did not stop at portraits, and the enterprise of more than a century of modern photography has vastly extended the horizons of ensouling. The anthropologist William Christian Jr calls this the power of 'activating' objects, of transfiguring them from one state – merchandise, commodities, trash or junk – into something with power.[2] Such a performative act of animation has often been described as uncanny; the photographic state, neither quick nor dead, has even come to define the uncanny. But perhaps this term, so over-used, boxes in the feelings that the kind of images in this book excite, and narrows their power. For such photographs of things show how photography can fill objects with meaning: their state then occupies another dimension which is not simply that indeterminate condition of being neither animate nor inert, but the living space-time of mental envisioning, of the pictures that live inside consciousness after art has brought them to mind and conferred a different, new existence on them.

The critic Mikhail Epshtein, writing in 1988 on the affiliation between human and thing, declared, 'There is not a Thing – from a car to a button, from a book to a candy wrapper – that does not occupy a special place in culture, and bring culture within human reach. In doing this it demands from its owner a reciprocal attention and understanding. His own position in the world, the meaning of his existence, is determined by the totality of surrounding Things. A Thing fallen out of signification creates a break in the network of connections with others and oneself.'[3] This kind of thing-ness gives rise to thoughts beyond the image, thoughts suffused with those qualities like memory, desire and imagination, and with those coordinates like a moment and a place and appearance; photographs

place objects in a network of such connections, and move things – unknown, impersonal, from far away and long ago in some cases – into the living present of the symbolic order which is full of animate energy, sometimes called soul.

Epshtein suggested a 'new science of things', which he called 'realogy' – a form of material mysticism, invested in the object which, saturated with feelings, has acquired a life of its own and become a 'vesch', a thing with a soul. The relationship with relics is close, but not identical. Photographs can function like relics through their celebrated relation with the dead and with stillness, and they circulate among the group of viewers and set up bonds of knowledge held in common. Several hundreds of images now belong to everyone and live inside our eyes, and there are many examples in this book of photographs that have already entered this shared language (by Julia Margaret Cameron, August Sander, Edward Weston, Manuel Alvarez Bravo, Lee Friedlander), and many more that will take their place among the 'veschi' of cultural memory. But the things in these photographs do not have to belong to anyone special, historically or personally. Sometimes they might possess talismanic status (Mondrian's tulip in Kertész's photograph; Edward Weston's nautilus shell; Christine Keeler's chair), but often it is the photograph itself that performs the spell and can infuse what the anthropologists call *mana* into the most ordinary things.

This aesthetic and ethical spirit was perhaps first seen in action when ordinary objects filled Renaissance cabinets of curiosity; there nature, represented by rocks and shells and flora and fauna, played the part of a consummate artist, while the ingenious artefacts of distant peoples, however commonplace (creels, sandals, nets) were highly prized. When the humanist Francis Bacon staged Christmas revels in 1594 at Gray's Inn, his character 'the Prince of Purpoole' was encouraged to set up 'a goodly huge cabinet, wherein ... whatsoever the hand of man by exquisite art or engine hath made rare in stuff, form, or motion; whatsoever singularity, chance and the shuffle of things hath produced; whatsoever Nature hath wrought in things that want life and may be kept; shall be sorted and included.'[4]

This all-inclusive and transfiguring appreciation refuses to cast out anything as monstrous or disorderly, but instead delights in the rich variety of created things; such an all-embracing spirit flows still more strongly in photography, which has discovered beauty and interest in the humdrum, the unremarkable, and even the foul.

Things: A Spectrum of Photography 1850–2001 has been selected and arranged with fine discrimination and a lively love of each photograph's distinctiveness by the historian and curator Mark Haworth-Booth; the volume has been printed with the closest attention to nuance of layout, tone and detail, under the direction of the editor Mark Holborn. More than a hundred images, they were first displayed together in the exhibition *Seeing Things: Photographing Objects 1850–2001* at the Victoria and Albert Museum in 2002, and the sequence here follows the order of the show, moving through six interconnected sections: Natural Things, Artefacts, Reinventing Things, Givens, People and Things, and Making Things. Nearly all the works belong to the extraordinary photographic treasury of the V&A, which has a uniquely important history, for the Museum's foundation coincides with the earliest years of the medium. In keeping with the enthusiasm of its founder, Prince Albert, for modernity in arts, processes, manufactures, crafts, science and industry, the V&A was dedicated to accumulating modern inventions and documenting progress in arts and crafts. Photography and this museum developed and changed together – ever since 1852, when the V&A first started buying photographs. The era's vision of holistic creativity, spanning the whole long stretch of the arts – from lone works of private inspiration to profitable patents and factory production – finds an epitome in this most mysterious and modern of media, which is both the instrument and repository of exceptional individual imaginations and at the same time the vehicle of copying and dissemination, in the distinctive mass-reproductive style of contemporary communications. It's not too strong a claim to say that photography has altered the appearance of the world and the ways we think about it. It was mistaken to proclaim, 'From today Painting is dead'; it would have been more accurate to say, 'From today, nothing will ever look the same.'

Prince Albert presented the Museum with some of its first photographs, including the eclectic assemblages circulated in the pioneering visual encyclopaedia established in Silesia by a kindred spirit of the Prince Consort, the nobleman Alexander von Minutoli, in order to promote arts and crafts in the region. Forming a kind of imaginary museum or inventory of everything, these higgledy-piggledy and dishevelled still lives, collocating heaps of assorted things – here knives and weapons and glasses and goblets – began as a kind of catalogue illustration, but strike a beholder now with their concentration, for instance, on the glassiness of glass, backlit, luminescent as moonlight, crustaceous, infinitely intricate.

Such instances at the beginning show how often photographs had a purpose, as documents of record: Mark Haworth-Booth, for example, uncovered the work of Eugène Atget classified anonymously as part of the archives of architecture and design. Atget's quiet, fine-grained photographs of Paris and its streets and bedrooms and

suburbs and inhabitants have now come to define a kind of photographic looking in their precision of observation, their absence of affect, and the hauntedness of Atget's relation to silence and slow time: a hawker stands, holding his gay lampshades in an empty street (Atget's streets are almost always empty, as if the camera had made its subjects appear and, without its attention, they would not be there); on a classical urn, portly cherubs play in marble under shadowless light, while the graffiti give the year when the photograph was taken, 1903 – returning us, when we look at it now, to that moment. Every image holds time in its light, and is a kind of magical device, a 'subtle knife' which can cut an aperture into other worlds, some of them in the past that happened, others in the space and time of fantasy.

Founding images of the collection which Mark Haworth-Booth chose for his show and this book keep changing meaning in relation to their place in social history; even more intensely perhaps, they mutate because in the twenty-first century viewers have seen so many more photographs than the original makers and the pioneers that we stand on a multi-layered archaeological ground for aesthetic appraisal. Man Ray's publicity photographs for an electric iron and a light bulb and a toaster have cast off the propaganda aim of the 1931 commission and have become inaugural acts of modern taste; these irradiated images, in which a luminous and translucent hand grasps a spectral instrument long superannuated as any kind of domestic tool, then underscored how photographic processes could far surpass the range and character of human vision, not just in concentrated and detailed looking, but in revelations of the invisible. The rayograph, like X-rays, like solarization, like microscopic imaging and other techniques of taking and making and printing, pushed photography beyond recording human visual experience into the ever-expanding territory where the medium forms cognition and even generates visions. Man Ray is not the only photographer represented in this selection to turn away from reproducing the sights of bodily eyes: the remarkable album of Laure Albin-Guillot, *Micrographie décorative*, published the same year (1931), applied the microscope to discerning 'writing in stones' (in Roger Caillois's phrase) – pattern and figure in natural stuff such as the hoof of a horse; Albin-Guillot intended her lovely, velvety, or even sooty studies to inspire decorative arts in the tradition of Art Nouveau. The camera was instituting new continuities between matter and imagination, as it enhanced the very faculty of vision. (When telescopes and microscopes were first invented, some scientists argued that these devices returned humanity to conditions before the Fall, for Adam and Eve would have seen without need of glasses or any other aids the craters in shadow on the surface of the moon, the hairs on a flea's legs and the scales on a butterfly's wing!)

Man Ray's fame and the brilliance of his inventions have given him pride of place among artists who demonstrated the symbiosis between human faculties – memory, visualization, fantasy – and photographic ways of seeing, thinking and imaging. Many others included here have impressed their vision in similar ways: we recognize an Edward Weston rhythm of form and shadow, an Irving Penn arrangement of elegance and simplicity, a Diane Arbus figure, a William Eggleston scene, and so forth. Indeed, it has become difficult to see the US, for instance, without framing it in the mind's eye from postcards and photographs taken by Walker Evans, Berenice Abbott or Lee Friedlander.

The collection has been explored, sifted, enriched and supremely well cared for since 1977 when Mark Haworth-Booth became Curator of Photographs. He continued with flair and boldness the early programme of acquisition, and, noticing the turn of contemporary artists to the medium, was inspired to buy major works such as the whole installation *The Oval Court* by the artist Helen Chadwick. Chadwick created this rococo meditation on vanity and pleasure with a photocopier and blue toner, steeping her images in reflections of Herschel's sumptuous invention, the cyanotype, and its exquisite application in the anatomies and botany of Anna Atkins as long ago as the 1840s. Under Mark Haworth-Booth's guidance, the V&A became an important patron of contemporary photographers, giving artists discriminating but undeviating and generous support in early phases of their careers when they were still affordable: this was the case with Helen Chadwick, and also with Hannah Collins, Adam Fuss, Jem Southam, Mari Mahr, Neil Reddy and Edgar Lissel. Lissel's numinous angel, taken in the Museum's medieval sculpture galleries by fitting out a display case as a camera obscura, opens this book's sequence of images. The angel's dematerialized body, caught without lens or apparatus, conveys the paradoxical thing-ness of the photograph, which partakes of the ethereal nature of heavenly beings, its subjects being both there and not there, its substance being so insubstantial, just a film of emulsion or whatever, composed of elusive 'image-chair' or image-flesh alone.

If some of the things in this book were indexed, its store would make fine tables about the wonder and properties of things, the tremendous diversity of the world (the ultimate consolation for some of the other things that happen too). Such an index might begin 'amulets (phallic)' and end with 'vanity case' or 'waterfall'; it might comprise 'badges (Support Our Boys; Boss Boy); bandages; baskets; birds (game;

Christmas); birthwort; blankets; boots; bottles (cut glass; scent; melted by H-bomb); bread rolls (Picasso's hands); calligraphy (cheque; vase; rat traps); candlesticks; Che Guevara; compact; corset; crocodile; dandelion; decay; diamond ring; dish; dividers; dollar bill; duck (eider, mallard, dead); ewer; ferns; fish; flintlock; flowers (wreath, wallpaper, border, artificial – see also apple blossom, lilies, lilies of the valley, roses, iris, giant hogweed, tulip, pink, etc.); fruit (mangosteen, pawpaw, tree tomato, melon, apples, watermelon etc.); gas-mask; ghost; glasses (spectacles, goblet, chalice, tumbler, centrepiece; decanter, cruet, etc. – see also bottle, mirror); graffiti; guitar; hairpin; handbags; harness bells; haystook; hoof (horse's); insects (dragonfly, beetle); iron; jelly moulds; keys; knives; lamps (lighthouse; light bulb, lampshades, bedside, oil – see Milky Way); lipstick; lizard; Mondrian; motorbike; needle; onions; pawpaw; pheasant; postage stamps; pots (and pans, dishes; jugs); prickly pears; prison cells; puddles; queens (Victoria, Elizabeth); sabre; scimitar; shells (nautilus, oysters); skeletons (human, gorilla); skulls; spices; spoons; stereo viewer; suburbs (US); swan (ghost); swords; tears (crystal); telephone; toaster; toilet bowl; toys (sailing ship); trousers (spongebag); turban; urn.'

But these are only a scant handful of the things in this book which photographers have made the subject of their composition or included by happenstance in their images. Like a list in a nonsense poem by that pioneering photographer, Lewis Carroll (' "The time has come," the Walrus said, / "To talk of many things: / Of shoes – and ships – and sealing- wax – / Of cabbages – and kings – " '), the images in this book are passionate with delight and point even when the subjects are as simple as saucepans, or as sobering as the prison cells in Jonathan Bayer's studies, or as tragic as the bottle twisted by the Nagasaki firestorm into a flayed torso, taken by Shomei Tomatsu in 1961.

In *One Hundred Years of Solitude*, one of the Buendias sticks pieces of paper on things with their names written down while he still knows them, because he is losing his memory of them and of his life amidst them, and falling out of connection. Like this act of claiming existence, like a register before judgement-seat of the way we lived and the civilization we made, these photographs bring the world into a book.

But listing the things in the images only gives one angle of view on the photographs collected here; it misses altogether their qualities as they are newly discovered to our eyes by the photographers' work and by the selection made. An index of the properties of things as brought out by the photographs would look a little different: it would tell of craquelure and fluff, the scales of fish and the rind of fruit, the spikiness of cacti, the shine of mirror and the softness of petals, dust particles and hairballs, flaking paint and drying ink, tears in fabric and gouges in stone, the gleam of satin and Bakelite, the sheen of skin and the liquid of puddles. In short, it would have to comprise the stuff and matter of the world in all its particularity, as well as its generic and inherent character – of its 'pied beauty'; 'the shuffle of things', their quiddities.

If Saint Jerome in his study in the painting by Bellini or Melancholia in the celebrated engraving by Dürer were wondering about the things surrounding them, about the quill or the Platonic solid, the astrolabe or the little dog or the pile of books, the word that might have come to their minds in that time, when thinkers pondered the nature and essence of things, is quiddity. Quiddity stumbles to name the thing-ness of things, reaches towards something they have and which seems hidden inside them. Quiddities can be grasped through establishing by absorbed attention to 'the proper difference of things'. There's a sister word, haecceity, this-ness, here-and-now-ness, which brings things a little closer in, into the pool of ambient light around the saint or Melancholy, and admits that there must be an observer, that subjectivity is always active when someone tries to grasp the quiddity of things.

Photographers have a special relation to the mystery of thing-ness, for a photograph so often reaches out to possess and stay the moment when the thing was there, in that here-and-now that was happening when I was there or you were with a camera or another means of making an image. The phrase, 'un je ne sais quoi', denoting that indefinable something – fugitive essence, mysterious allure – has sadly become tired (a cliché – itself a word meaning take, impression, print, arising from the photographic age), but it relates to this-ness and to quiddity and to photographs, because what they do when they communicate the image of things cannot be reconveyed in words or translated into any another medium; there is the quiddity of things which photographs explore, and besides, as the book here reveals in image after image, photographs have their own being, are themselves a subject with their own quiddity. If a photograph is a thing too, what kind of a thing is it?

A photograph makes the world visible to us, turning whatever its subjects are, however natural, into artefacts, and in that fusion, redefining the marvellous and the wonderful. This book also comprises images in every kind of photographic process, both of making and of reproducing and printing (another possible index, from Albumen to Xerox?), but the dates – 1850 to the present – encompass modernity, for photography reproduces, shapes and defines so much more than the objects of the camera's vision. It has mediated consciousness itself, since Julia Margaret Cameron and

others among the pioneers continued the Romantics' enterprise and turned their cameras to catching the images formed by 'that inward eye that is the bliss of solitude'.

As the coming of the wireless in the late nineteenth century inspired the dialogue resonating in the minds of characters in fiction (the voices in the head, or stream of consciousness, in Woolf's *The Waves*, for example), so the photographic image mimicked and then enhanced the brain's functions, acting as an indispensable prosthesis in our lives, as the vehicle of memory, an instrument of inquiry, the medium of desire and longing, and the engine/generator of contemporary metaphor and symbol.

Photography's relation with the past, with death and loss, and its function of stilling the flow of time and preserving transitory things, has received eloquent appraisal from Barthes and Susan Sontag; recently photographic writing, such as the fiction of W. G. Sebald, has deepened the affinity between elegy and the enigmas of captured memories. But this emphasis has perhaps overshadowed the medium's long, deep intertwining with expressions of dreaming and desiring, and many of the things in this selection seek out visual correlatives for all kinds of fantasies: the evident delight and humour of the twinned onions in the gardener Charles Jones's still life of *c*.1895–1900; the erotic *mises-en-scène* of Manuel Alvarez Bravo, including the famous nude, lightly bandaged and lying in the sun beside prickly pears; Fats Domino's big bad jewellery.

Writing about things with souls, the Russian artist Ilya Kabakov emphasized that many circulate as part of the secular sacred lexicon of our imaginations today and 'depict the ordinary, banal … and the commonplace …' He went on, 'The metaphysics of the commonplace is a very interesting pursuit, because metaphysics assumes a field of activity which is either lofty or earthly, either heaven or hell. The grey, the middling, the banal, it would seem has no metaphysics … And precisely this attracted me more and more.'[5]

This album of *Things* could be seen as a *Wunderkammer* in the spirit of a metaphysics of the commonplace, a common cupboard of stuff here transvalued through photography and the many passionate and inventive forms of attention photographers have given to the deep and mysterious world of appearances.

[1] The term 'vesch' is used differently from 'predmet', in ways analogous to the English 'thing' versus 'object', but not identical. See Tim Travis, 'Things with Souls: The object in late Soviet culture', *things* 12, Summer 2000, p.42.

[2] I am grateful to William Christian Jr for conversations about his work on 'things', and for sending me his unpublished paper, 'Yard Sale: Activation and loss of personal value in objects', given at the Getty Center, 17 September, 1998.

[3] Mikhail Epshtein, 'Things and words; Towards a Lyrical Museum', in *New Paradoxes* (Moscow, 1988), *Tekstura: Russian Essays on Visual Culture*, edited and translated by Alla Efimova and Lev Manovich (Chicago, 1983), quoted Travis, p.42.

[4] Francis Bacon, *Gesta Grayorum*, in *Works*, Vol.8, pp.334–35.

[5] Travis, p.53.

1

Photography was described by its British inventor, W. H. F. Talbot, as 'The Pencil of Nature'. The new medium used the laws of chemistry and physics to create authentic, superbly detailed descriptions, which surpassed and – from around 1850 – generally replaced earlier graphic media. In the beginning such images were produced directly by the objects themselves, without the intervention of a camera or lens. Recording the delicate structures of natural things showed off the brilliance of the new medium. The botanist Anna Atkins arranged plant specimens on sensitized paper and let sunlight do the drawing. She delighted in the beauty of the resulting images. The technique, known as photogram, is used to this day. The recent examples here were made by Angela Easterling at the Eden Project.

Pioneer photographers attempted still-life compositions in emulation of painters, but even if – like Roger Fenton or Emma Schenson – they were making documents, each photograph was an interpretation, a challenge involving choice of lens, lighting, viewpoint, processing and printing. This section includes photographs that both celebrate and preserve, inform and inspire. Some were made for purposes at which we can now only guess. In modern times, photographers have found symbols and metaphors in natural things and created images that question our assumptions about nature.

Natural Things

Angela Easterling
British, born 1944

Sterculia quinqueloba (Large-leaved Star Chestnut), 2001
Gelatin-silver print (photogram)
47.5 x 40 cm

Given by the Eden Project, St Austell, 2001

Angela Easterling is investigating the properties of plants with scientists at the Eden Project in St Austell, making images that are determined by the volatile and unexpected reactions of plants – with their varying densities and chemical make-up – in contact with photographic paper for black-and-white printing and with sunlight. Here she demonstrates the difference in density between leaves high up on a tree, through which much light passes, like the chestnut leaf, and those nearer the ground, like the balsa leaf, which need to absorb as much of the available light as possible.

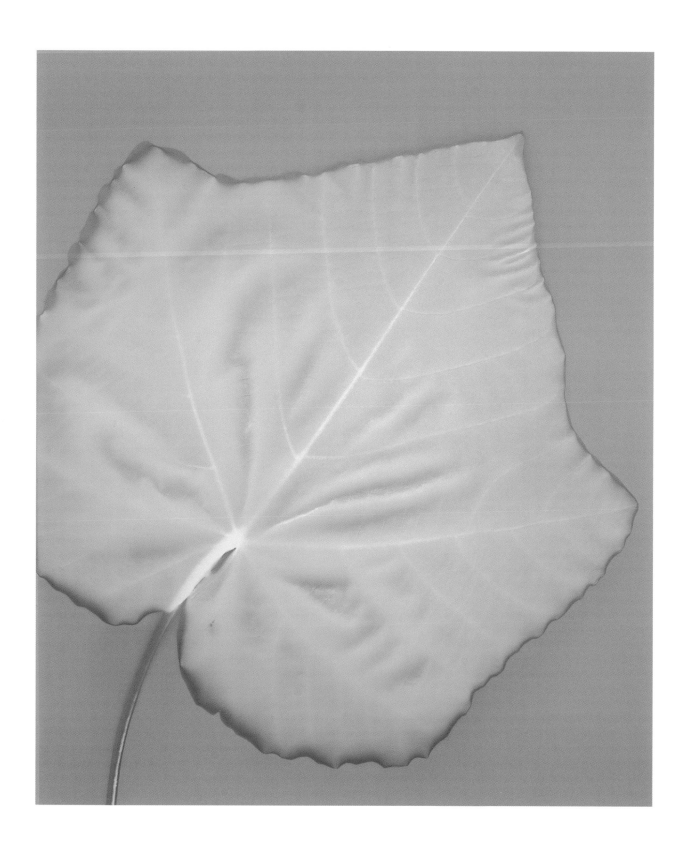

Angela Easterling
British, born 1944

Ochroma lagopus (Balsa), 2001
Gelatin-silver print (photogram)
47.5 x 39.5 cm

Given by the Eden Project, St Austell, 2001

These magnificent works, reproduced on pages 15 and 17, represent the meeting of science and art, representation and symbolism in one act. The phrase 'Ways of Seeing' could never be more appropriate than here.

Two leaves, not much different in form, adapted to perform at extremes. Beneath the surface a natural system, hundreds of times more efficient than any power station yet invented, turns sunlight into food and creates the very air that we breathe – in silence. So sophisticated that one lives in the full glare of the light absorbing through its translucent skin like a Japanese screen. The other is impenetrable, holding a darker secret. What strange alchemy can allow it to live in the gloom of the forest floor and – taking in only minutes of light a day – thrive? Scientists are obsessed with revealing the how, but for us ordinary mortals what we need to know is that one of the great mysteries of life is represented within this living, breathing pair of pictures; the glow of power, the beauty of nature and what is the appropriate response? Humility.

Tim Smit, founder of the Eden Project

Anna Atkins
British, 1799–1871

Dandelion, early 1850s
Cyanotype (blueprint)
35 x 24.6 cm

Atkins was the world's first woman photographer and the first person ever to print and publish a photographically illustrated book (*British Algae*, 1843). She was skilled at drawing shells and other natural specimens before taking up what she called 'Sir John Herschel's beautiful process of cyanotype' as soon as it was invented in 1842. Her motivation was surely aesthetic as well as scientific. This is probably the first photographic portrait (or self-portrait?) of a dandelion. It comes from Atkins's finest album, which she presented to her friend and co-photographer Anne Dixon in 1854.

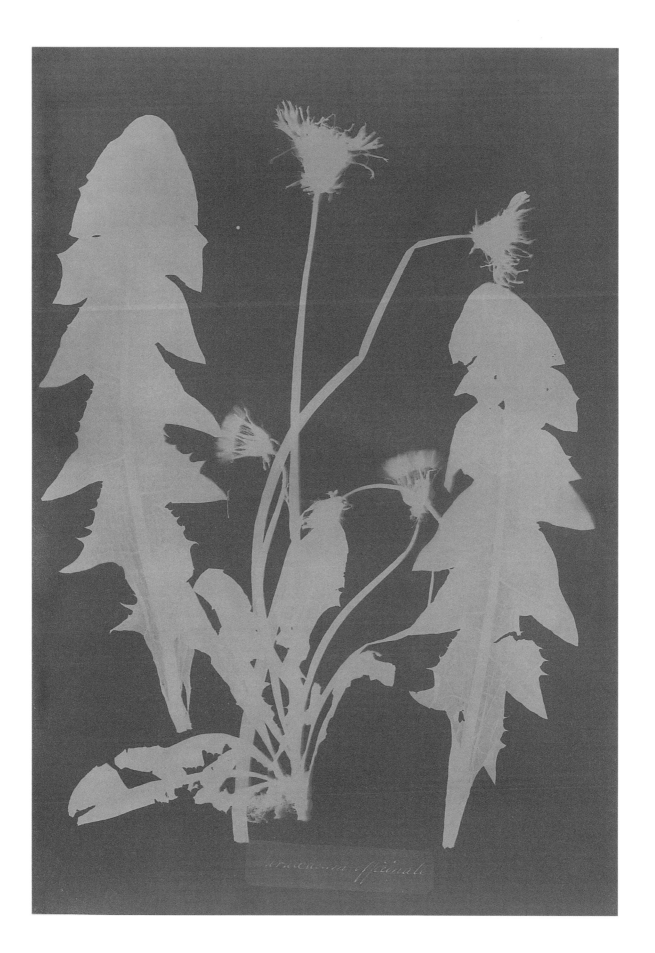

Roger Fenton
British, 1819–69

Skeletons of a human and a gorilla, *c*.1855
Salted paper print from wet collodion on glass negative
36.5 x 28 cm

There is nothing special to be said about the human skeleton, apart from the fact that it is probably of a European. The gorilla, however, shows evidence of severe trauma to its left arm, e.g. a bite from a lion to the lower part of its left humerus. Gorillas don't spend that much time 'standing' upright and that is because it takes muscle energy for a gorilla to do so. Thus, the supposedly 'neutral' presentation of a gorilla skeleton is in fact the presentation of an idea: 'gorilla standing is not too different from human standing'.

Dr Robert Kruszynski, Natural History Museum, London

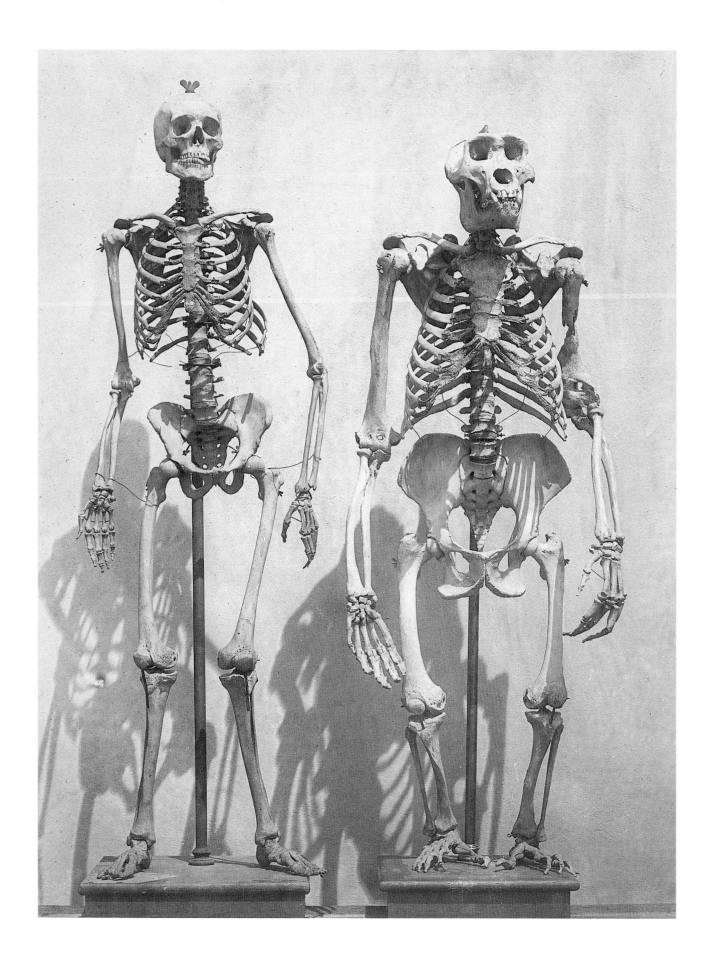

John Dillwyn Llewelyn
British, 1810–82

Sewin, 1853
Salted paper print from glass negative
15.5 x 20.6 cm

Sewin is the colloquial Welsh name for the sea-trout, a migratory brown trout which, like the salmon, spends time feeding at sea before returning to the river of its birth to spawn. Sea-trout are highly prized by anglers for their strength, beauty and elusiveness; and by chefs for their delicately flavoured flesh, which is tinted pink by a sea-diet of shrimps. This fine specimen is shown displayed on a traditional bass bag made of rush which, when soaked with water, keeps the fish cool by evaporation. A boxwood four-fold carpenter's rule has been included to show scale.

Peter Warren

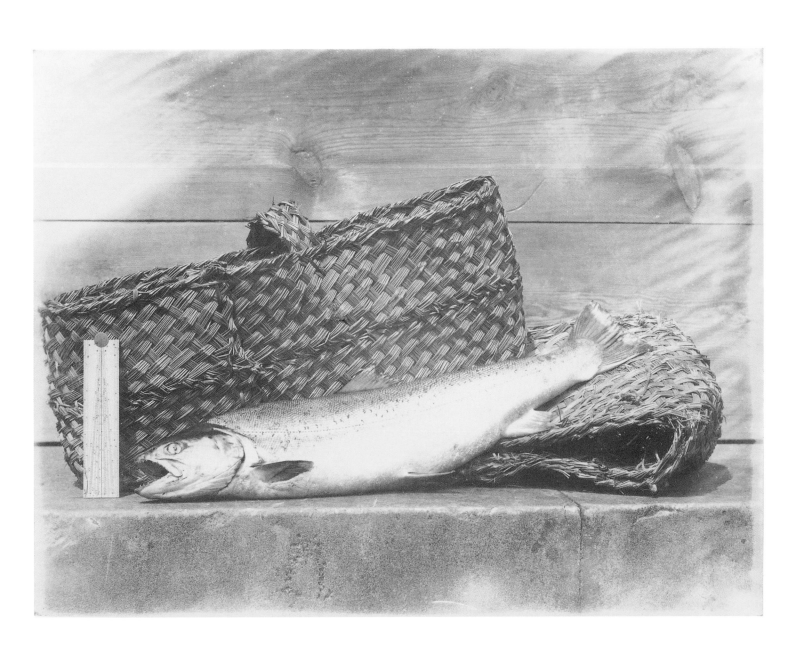

Victor A. Prout
British, active 1850s–60s

Christmas Fare, 1855
Salted paper print from collodion on glass negative
Signed and titled on mount, also inscribed: 'Collodion'
36.8 x 27.4 cm

This is one of the first art photographs acquired by the V&A. It was bought by Henry Cole, the museum's founding director, who saw it at the annual exhibition of the Photographic Society of London, held in a gallery off Piccadilly in 1856. Like other photographers of the time, Prout emulated the still life of the easel-painting tradition. By choosing a matt salted paper on which to print, Prout muted the sharp actuality that is the signature of collodion negatives.

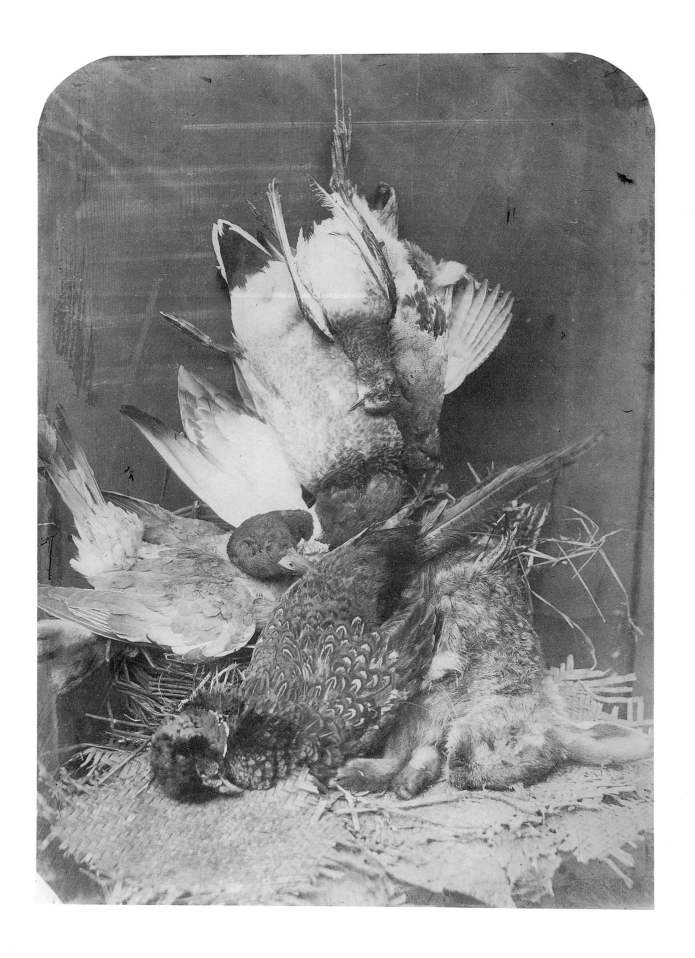

Adolphe Braun
French, 1812–77

Wreath: apple blossom, rhododendron, lilies of the valley, *c.1855*
Carbon print (1870s)
36.8 x 44.2 cm

Braun worked in Mulhouse in south-eastern France as a designer, with a studio staff of 40, before turning to photography. Wallpaper manufacturers in the town sometimes maintained greenhouses so that designers could work directly from flowers. Braun's flower photographs – which launched his new career – allowed every designer (and artist) the opportunity to work from natural models. This is presumably why 17 of his large flower photographs were bought by the Museum in 1875. The flower series remained in the Braun et Cie catalogue until 1887.

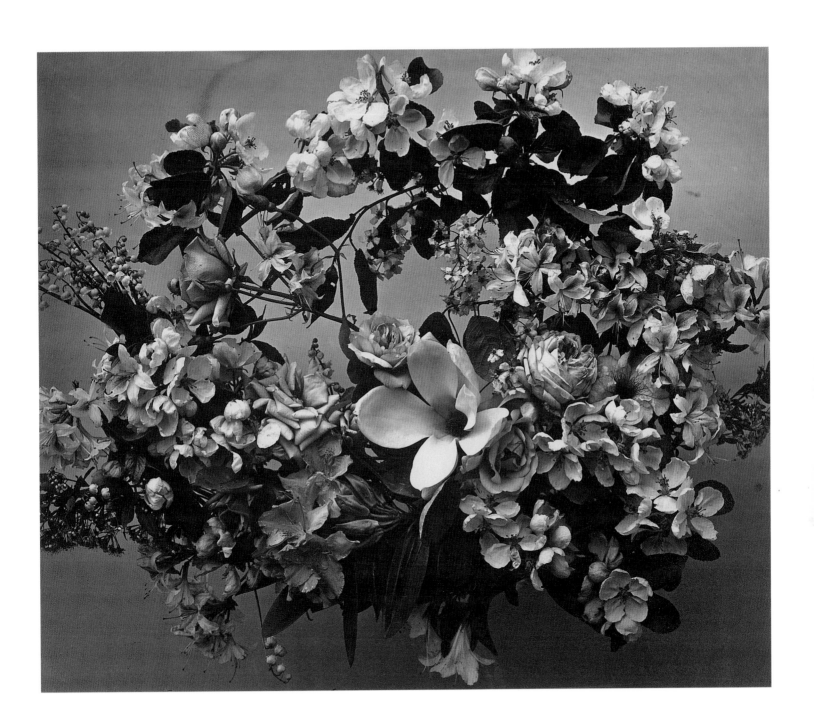

Emma Schenson
Swedish, 1827–1913

Linnaeus Bedroom, 1864
Albumen-silver print from glass negative
16.3 x 13.8 cm

In 1864 the Swedish photographer Emma Schenson made a series of photographs in memory of the Swedish botanist Carl von Linné (1707–78), who called himself Linnaeus. Most photographs of the series were taken in his house (now a museum) in Hammarby, near Uppsala. Linnaeus furnished his home as a kind of personal museum. Almost every detail of the arrangement has a close relationship to his work. In the bedroom the wallpaper is made from proof copies of drawings by Charles Pumier (French botanist, 1646–1704). The curtain on the bed is printed with a decoration based on his favourite flower, the *Linnaea borealis*.

page 30

Memorials of Linnaeus, 1864
Albumen-silver print from glass negative
18.2 x 14 cm

Schenson's practice as a painter (as well as a photographer) is evident here. She used a painting by Johan Henrik Scheffel (1755, still in Hammarby) as part of a lively composition. She placed objects of the botanist's daily life with the painting, such as his hat, teacup, teapot, tea caddy. His walking stick leans against a chair, as if its owner might return at any moment. Schenson indicates also Linnaeus's place in an ancestral portrait gallery, positioning Scheffel's painting so that the sitter's head appears in line with the two female portraits (his wife and his mother?) on the wall in the background.

page 31

Linnaea borealis L., 1864
Hand-coloured photograph
12.4 x 14.8 cm

The hand-coloured photograph shows the initial of the famous botanist. The letter 'L' is created by the *Linnaea borealis* (twinflower), the flower of Linnaeus's coat of arms. Linnaeus introduced the consistent use of binomial terms for both plants and animals. In this system of nomenclature every name has two parts, the first for the genus and the second for the species. To the names of plants that he was the first to describe, Linnaeus added his initial 'L', following their names. Thus the initial created by Linnaeus's favourite flower epitomizes his work.

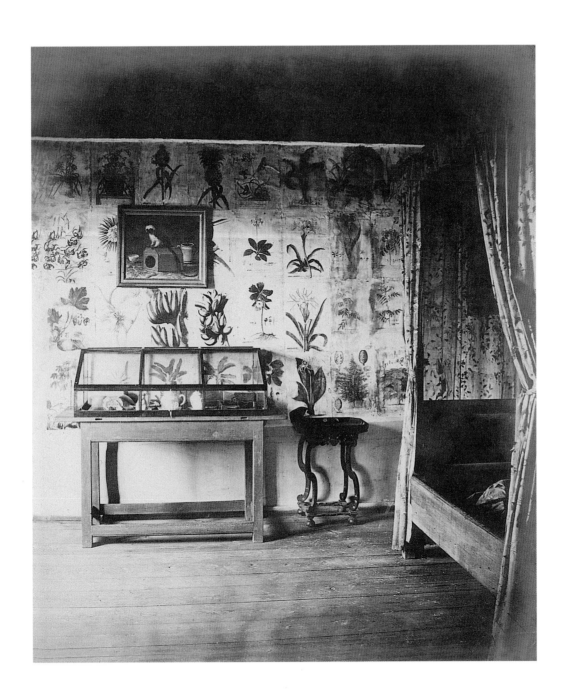

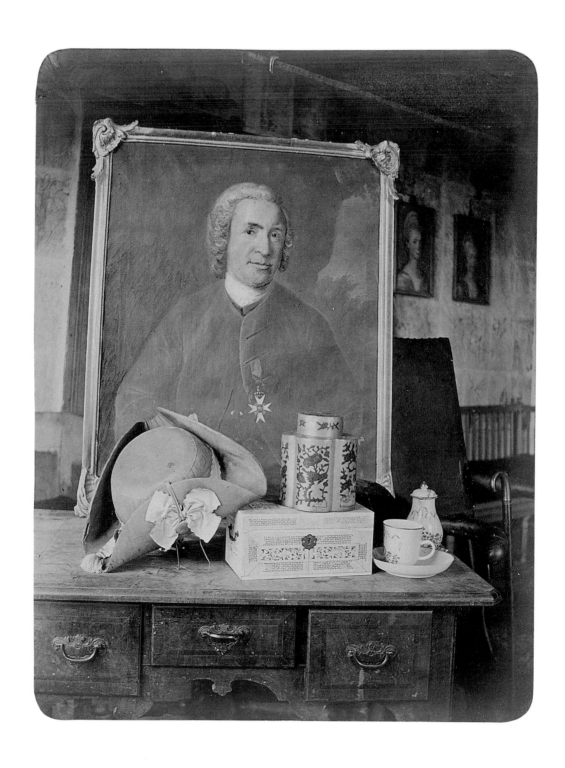

Skeen & Co.
British, active 1860–*c*.1900

Still life of exotic fruits from Sri Lanka, *c*.1880
Albumen-silver print with decorative border
in watercolour with postage stamps
Signed in the negative: Skeen & Co.
39.5 x 30.2 cm

Given by Adrian Sassoon, Esq., 2001

H. W. Skeen founded the company in 1860 in the port city of Colombo. His son William Louis Henry Skeen was born in Ceylon (now Sri Lanka), studied at the London School of Photography and joined the family business in 1862 or 1863. The firm's work concentrated on the commercial life of the island, but also produced pictures – like this one – for naval, military or merchant travellers and the bureaucratic class. It was the great period for the introduction of exotic plant species to Europe. The decorative border added by its original owner makes the photograph an object in its own right.

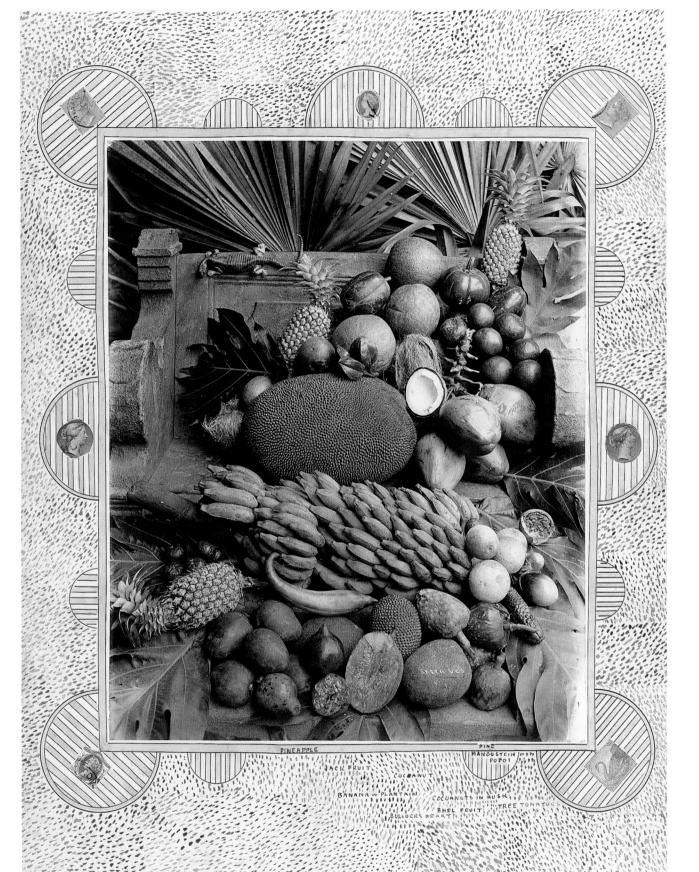

PINEAPPLE PINE
 MANGOSTEIN
 POPOI
JACK FRUIT COCOANUT
BANANA or PLANTAIN COCOANUTS IN HUSK
 BHEL FRUIT TREE TOMATOES
 BULLOCKS HEART

Anonymous

Human skull, *c*.1880–1900
Photogravure
17.5 x 15.3 cm

This skull seems to float in space and parts have been removed. The skull was mounted on a wooden panel and prepared for teaching purposes. Dr Robert Kruszynski of the Natural History Museum writes: 'The photograph shows the right side of an adolescent (or young adult) human female skull which has had the out-bone of the right side of the maxilla and the corpus mandibulae removed to reveal the roots of the teeth and unerupted teeth. It may be of a skull kept in the Royal College of Surgeons because the mode of preparation is typical of that College.'

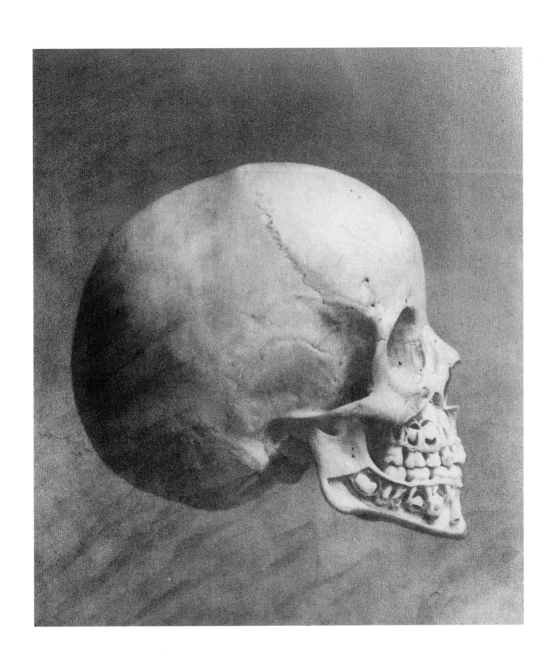

Frederic Eugene Ives
American, 1856–1937

Geological diagram by Colin Campbell Cooper
Three-colour process print (Ives process)
15.7 x 10.7 cm

Given by F. E. Ives & Co., New York, 1905

The photograph is of a thin section of a rock probably taken for publication or demonstration purposes. The thin section was made by cutting a slice from the rock and grinding it so thin that light can pass through it. The section is viewed in a microscope to reveal rock structures and for mineral identification. The angular fragments of brown banded material are likely to be chalcedony, which has been broken up and the fractures filled with quartz. The quartz crystals show as white, grey, blue and orange patches. The Victorians were interested in the structures and origins of rocks, but also enjoyed their aesthetic qualities.

Ben Williamson, Natural History Museum, London

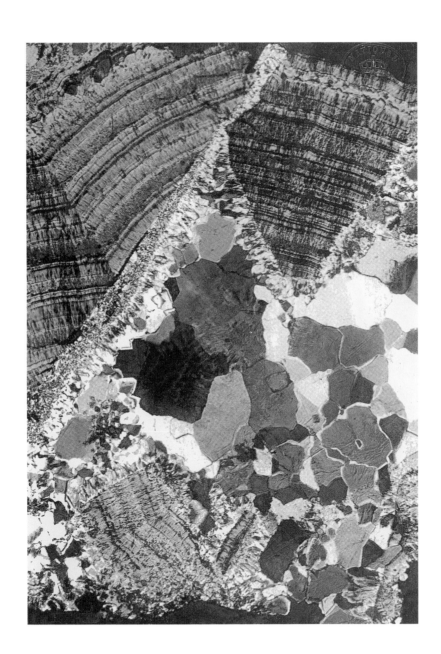

Charles Jones
British, 1866–1959

Melon, Hero of Lochinge, *c.*1895–1910
Gelatin-silver print; gold-toned printing-out paper
16.5 x 21.5 cm

Given by Sean Sexton, 1981

Charles Jones worked as a gardener at, among other places, Ote Hall in Wivelsfield, Sussex. He made photographs of the produce and flowers he grew, but did not exhibit or publish them. His photographs might have passed into oblivion but for the author, collector and photography dealer Sean Sexton. He bought a trunk of the photographs at Bermondsey antique market in 1981 and has subsequently nurtured the photographer's reputation internationally. Instead of developing his prints chemically, which produces black-and-white prints, Jones printed his photographs by sunlight – hence their warm and subtle tonality.

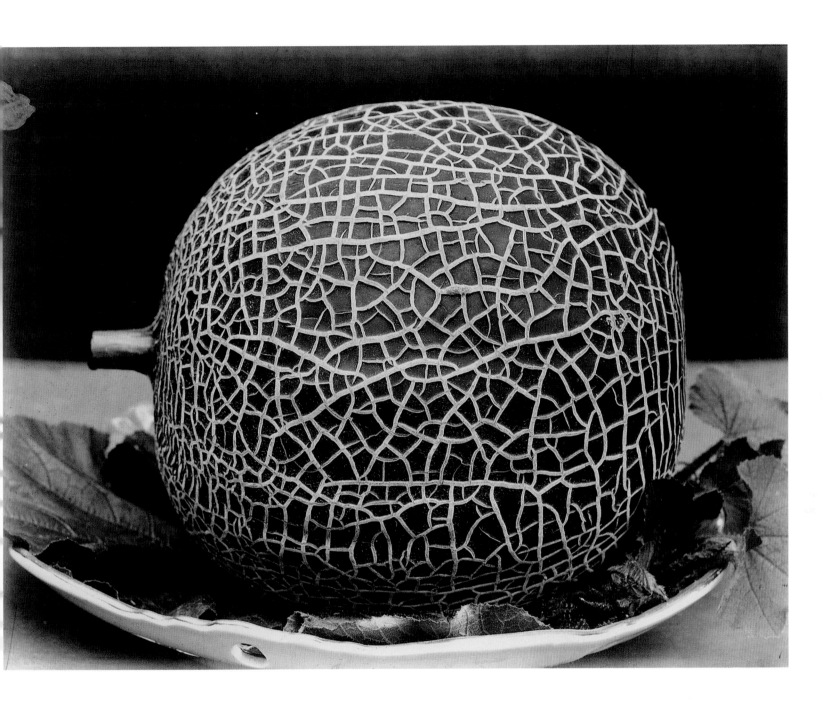

Charles Jones
British, 1866–1959

Onions, Ailsa Craig, *c*.1895–1900
Gelatin-silver print; gold-toned printing-out paper
16.5 x 21.5 cm

Given by Sean Sexton, 1981

The photographs by the gardener Charles Jones struck a chord when they were rediscovered in 1981 because they seemed to many critics and collectors to prefigure the style of great modernists of the 1920s. Jones positioned his fruits and vegetables in isolation against neutral backgrounds. His long exposures ensured depth of field and a full tonal range, including detail in highlights and shadows. If there is a latent eroticism in some of his compositions, it was surely unconscious – unlike the similar qualities to be found in such thoroughly self-aware masters as Edward Weston.

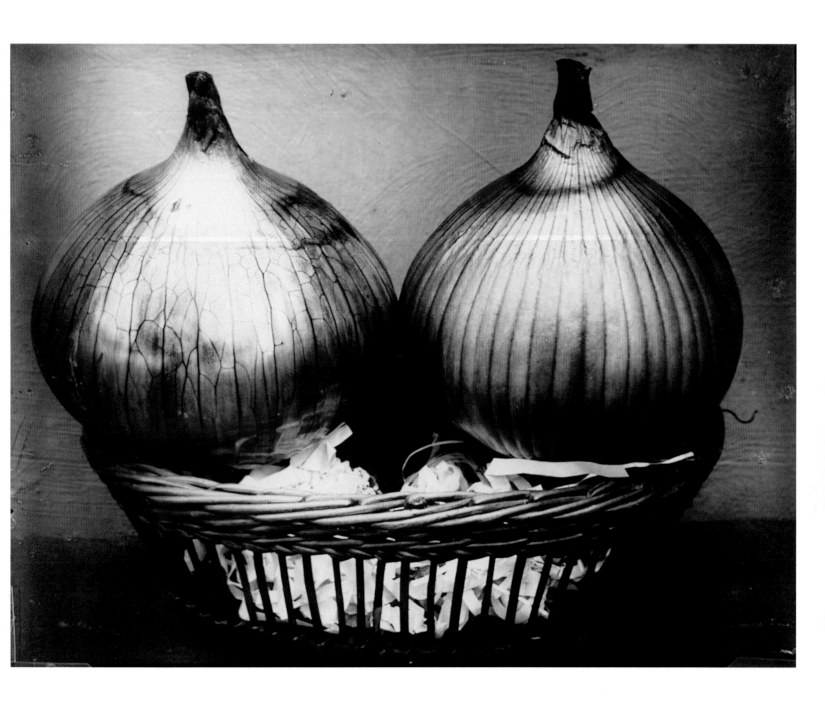

Edward Weston
American, 1886–1958

Nautilus Shell, 1927
Gelatin-silver print by Cole Weston (1980)
23.8 x 18.7 cm

Edward Weston wrote eloquently in his Daybooks for more than 15 years, both in Mexico (1923–26) and after his return to California. He wrote of the problems of photographing chambered nautilus shells – such as how to balance the shell on end while not losing any part of its form. He was aware of the sexual symbolism of these photographs, but noted that, while he was not blind to their sensuous quality, there were spiritual qualities too. The combination of both physical and spiritual elements in the shell 'makes it such an important abstract of life'.

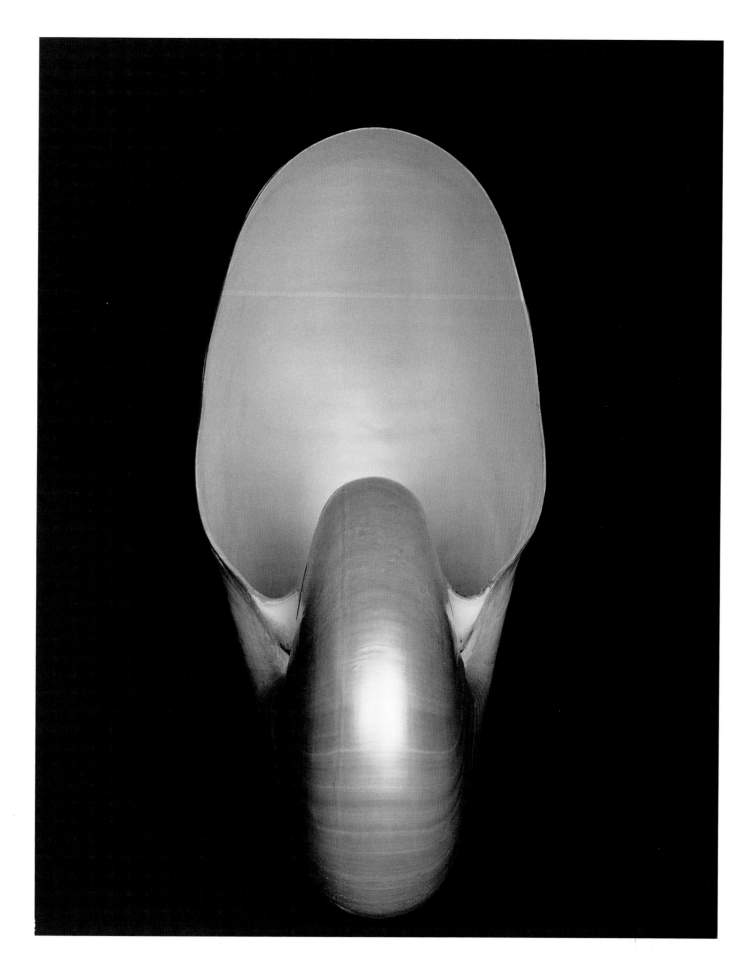

Paul Strand
American, 1890–1976

Iris, Georgetown, Maine, 1928
Gelatin-silver print by Paul Strand and Richard Benson (1975)
24.5 x 20 cm

Strand made photographs of unsurpassed subtlety of natural things. His *Iris* is perhaps as symbolic as the flower paintings of Georgia O'Keeffe, which Strand knew well. In *Time in New England* (1950), the book that he compiled with Nancy Newhall, this photograph is reproduced opposite touching words – impure in grammar, but nothing else – from the prison letters of the controversially convicted and executed anarchists Sacco and Vanzetti. In that context Strand's *Iris* became an image of enduring and uncorruptible strength.

Karl Blossfeldt
German, 1865–1932

Birthwort (*Aristolochia clematitis*), seven times enlarged
Pl. 25 from *Urformen der Kunst: Photographische Pflanzenbilder*
(*Source forms of art: Photographic plant pictures*)
edited and introduced by Karl Nierendorf
Published by E. Wasmuth, Berlin, 1929 (second impression)
Printed in half-tone by Ganymed, Berlin
26 x 19.5 cm

This detail of a birthwort attains a sculptural character, negating any vegetable quality, including its transitoriness. This is achieved by segmentation and enlargement.

Karl Blossfeldt, a professional sculptor and amateur photographer, worked in Berlin in the Arts and Crafts College. From about 1900 he created many series of plant details. He aimed to inspire artists and designers to good design by offering plant forms as models. He himself designed objects using plant forms, such as a nutcracker.

Curtis Moffat
American, 1887–1949

Dragonfly, *c*.1925–30
Gelatin-silver print
36.5 x 29 cm

Given by Penelope Smail, 2003

page 48

Curtis Moffat became a creative presence on the European scene in the early 1920s. He made Rayographs in Paris with Man Ray, and by the time of his first exhibition in London in 1925 he had photographed Nancy Cunard, Lady Diana Cooper and Tallulah Bankhead. In 1930 he opened Curtis Moffat Ltd at 4 Fitzroy Square, specializing in modern furniture and decoration. This photograph was made by a typically novel process: he placed a dragonfly in the enlarger and projected light through it onto positive paper. The image connects with the kinds of materials Moffat promoted in his design business – light and transparent perspex, silver carpets, lacquer and black glass.

Laure Albin-Guillot
French, 1879–1962

Pl. IV, Corne de sabot de cheval (horn of a horsehoof)
from *Micrographie Décorative*, 1931
Fresson print
27.5 x 21.5 cm

page 49

Albin-Guillot played a central role in the evolution of modern commercial photography in Paris in the 1920s and '30s. She produced a highly successful volume of micro-photographs illustrating the hidden structures of organic materials. The standard edition was printed in photogravure, but this is the author's own copy, printed in pigments by the Fresson process on coloured papers. The publication offered the patterns of nature as inspiration to modern designers. Albin-Guillot herself is said to have contributed decorative screens based on this series to the luxury liner SS *Normandie*, launched in 1935.

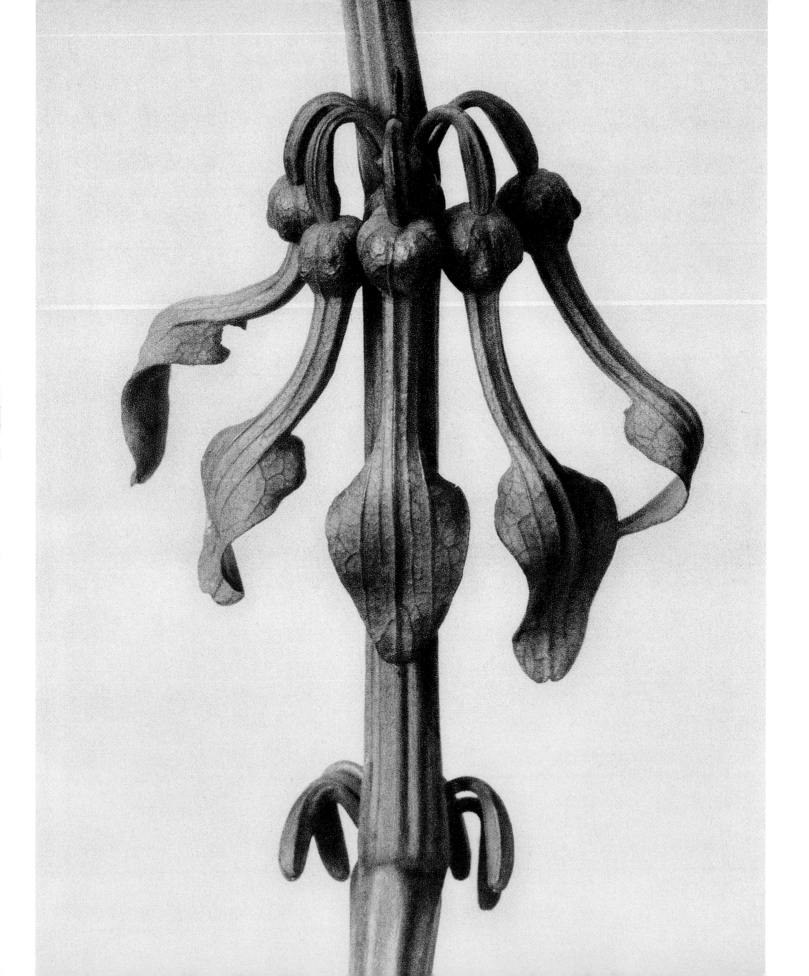

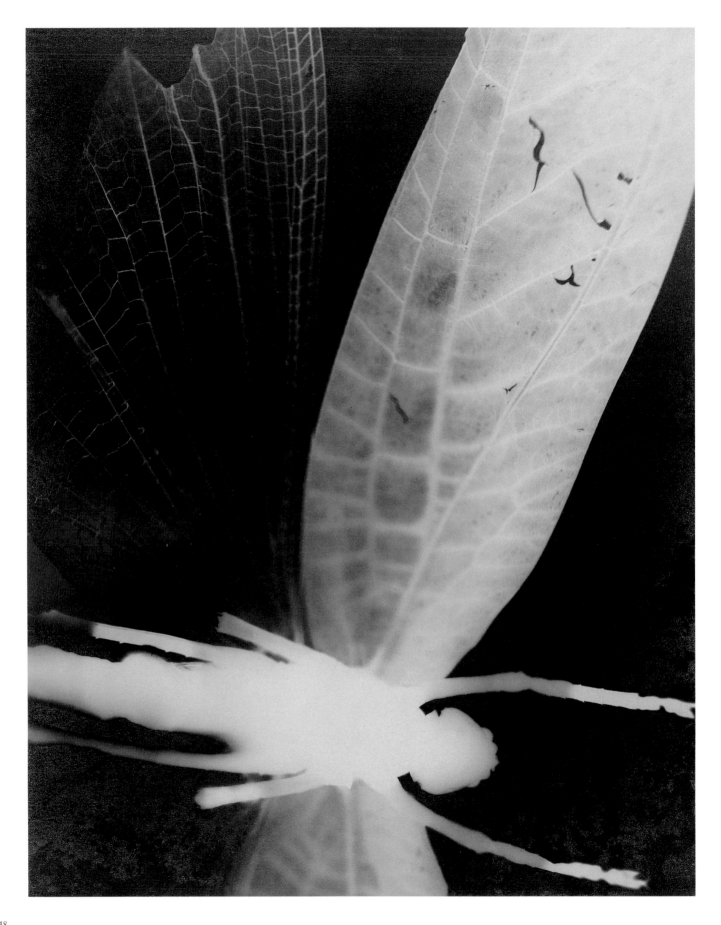

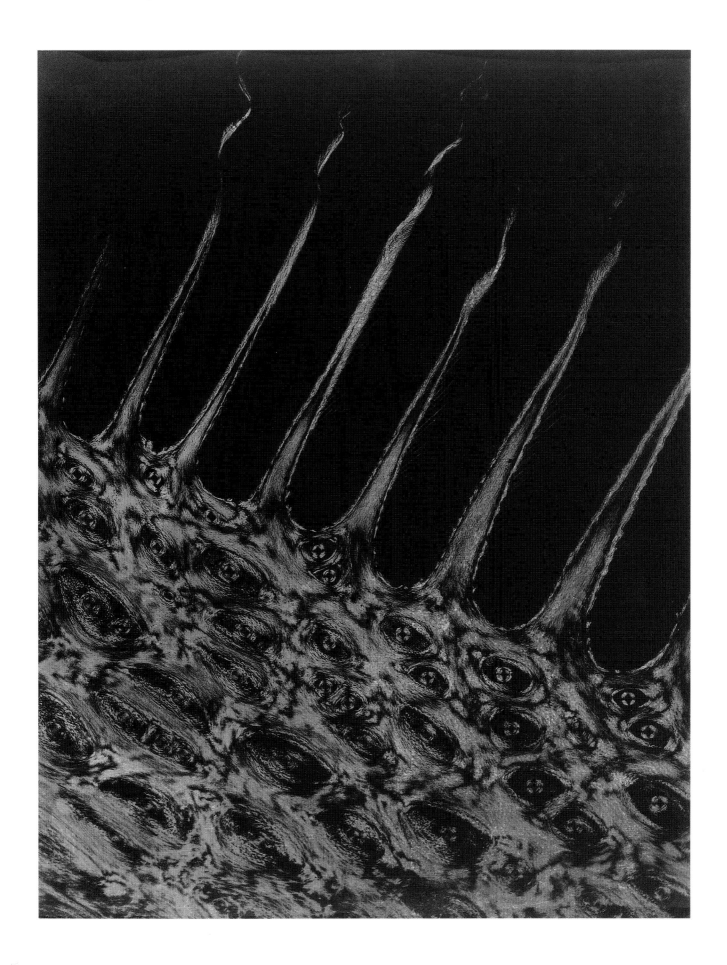

Paul Caponigro
American, born 1932

Apples, 1966
Gelatin-silver print (1980)
16.5 x 23 cm

Caponigro belongs to a tradition in American photography that could be described as transcendental. Its masters include Edward Weston, Ansel Adams, Wynn Bullock, Minor White and Caponigro himself. In this tradition, objects are represented in all their physicality, but are seen as aspects of a larger order of things. Thus Caponigro's apples are unquestionably apples, but the extreme delicacy of the grey scale with which they are rendered suggests that they have found a new role in the history of art – not as symbols of temptation, but of innocence.

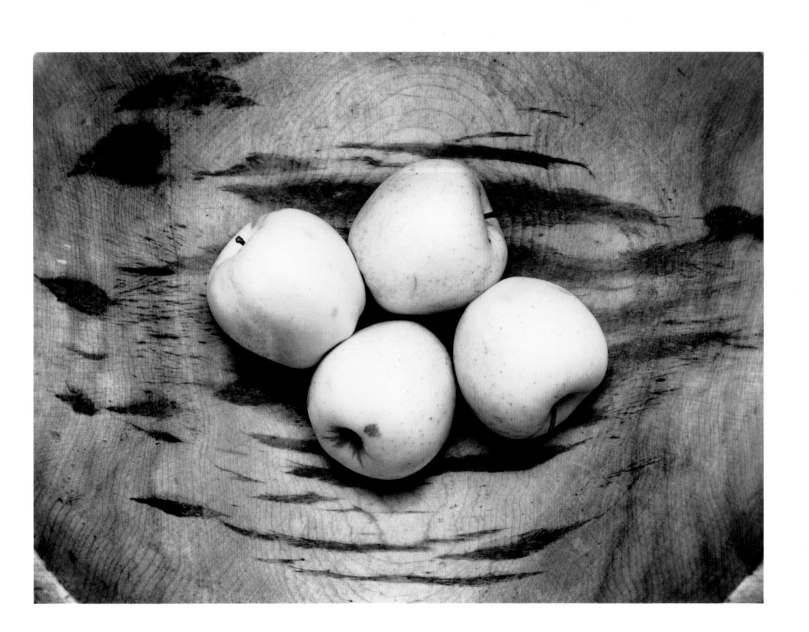

Peter Cattrell
British, born 1959

Giant Hogweed, Chatsworth Gardens, Derbyshire, 1986
Gelatin-silver print
26.8 x 26.8 cm

This was taken on my first visit to Chatsworth, and although it was midsummer, the light was bad and it was about to rain. I was walking through the garden, and turned a corner to meet this huge hogweed, about eight feet tall. It seemed to have a presence, like meeting a person unexpectedly. I chose to use the widest lens I had with me, to exaggerate the shape of the plant, but also to make the steps appear further away. I returned a month later and it had been cut down.

Peter Cattrell

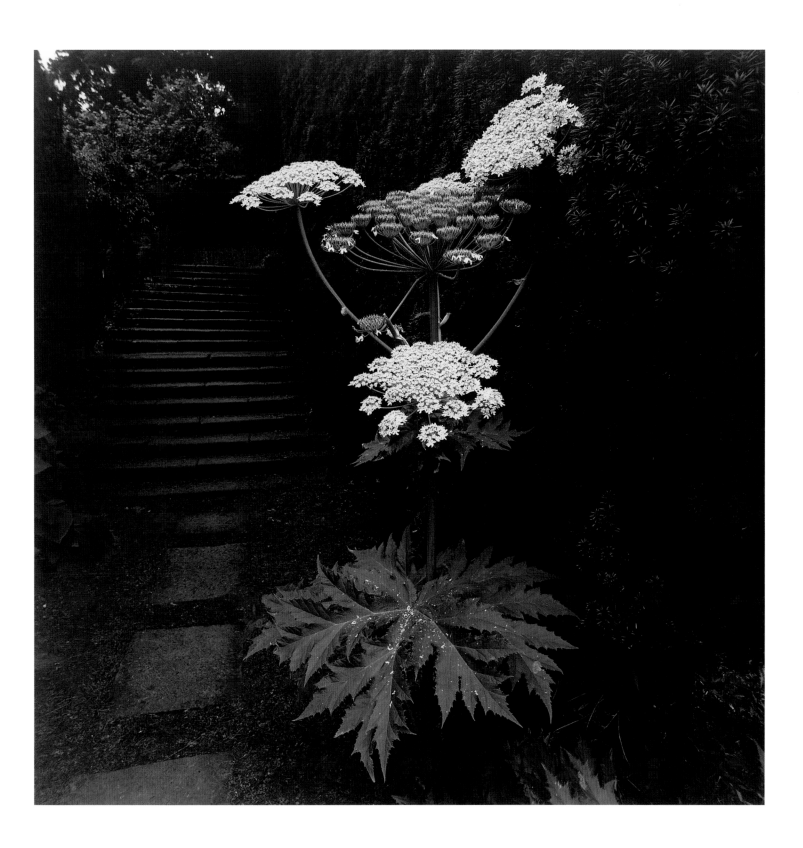

Charlie Meecham
British, born 1950

Bothwood Dam, Bothwood Reservoir, West Yorkshire, 1982
Ilfochrome colour print
33 x 42 cm

To help us read images and make them interesting, we often draw on our own experiences to help give context and meaning. In this case there is an ominous relationship set up between the fragile lace-like quality of the frozen water in front of the dam and our knowledge that behind it lies a dark weight of water that could do untold damage, should the dam give way. At the time of its taking, the potential of these forces gave rise to thoughts of an imaginary future within the photograph. That imaginary future is now superseded by the reservoir of accumulated memories.

Charlie Meecham

Roni Horn
American, born 1955

Untitled (To Nest), 2001
Signed, dated and numbered (15/100) by the artist on verso
Digital inkjet print
Published by Counter Editions, London, 2001
40 x 61 cm

Purchased from the Julie and Robert Breckman Fund
and the Sir Cecil Beaton Fund

following pages

Roni Horn is best known for minimalist sculpture. Her frequent trips to Iceland, since 1975, have become a major source of inspiration. This work looks superficially like a large-scale stereoscopic photograph. However, the doubling is used for poetic ends. Harvesting down from the vacated nests of eider ducks is one of Iceland's few surviving cottage industries. With eggs usually laid in pairs, the occurrence of a single egg is highly unusual. Horn's image also recalls the effect of the double, or *Doppelgänger*, described by Sigmund Freud in his 1919 essay on 'The Uncanny' – which creates 'an uncanny and thus a sublime atmosphere'.

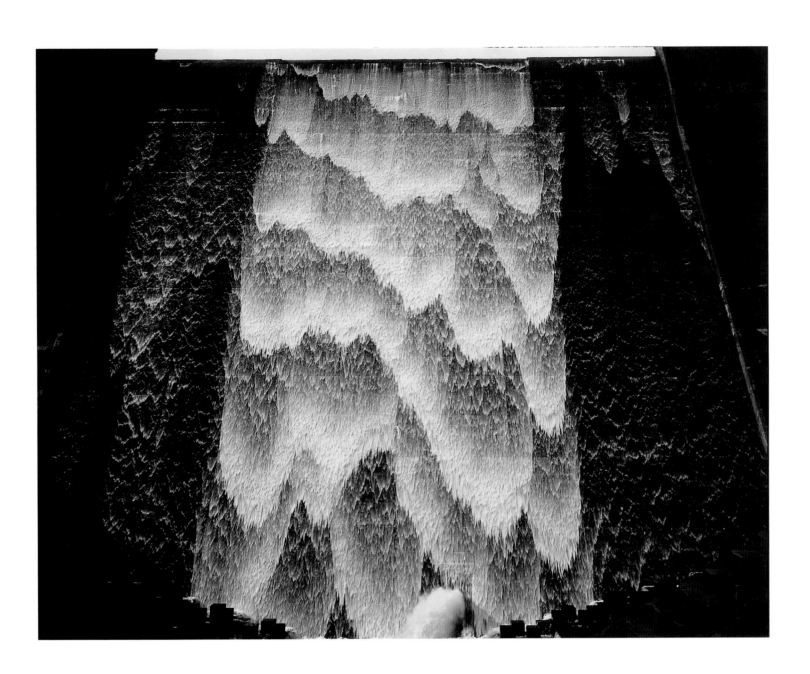

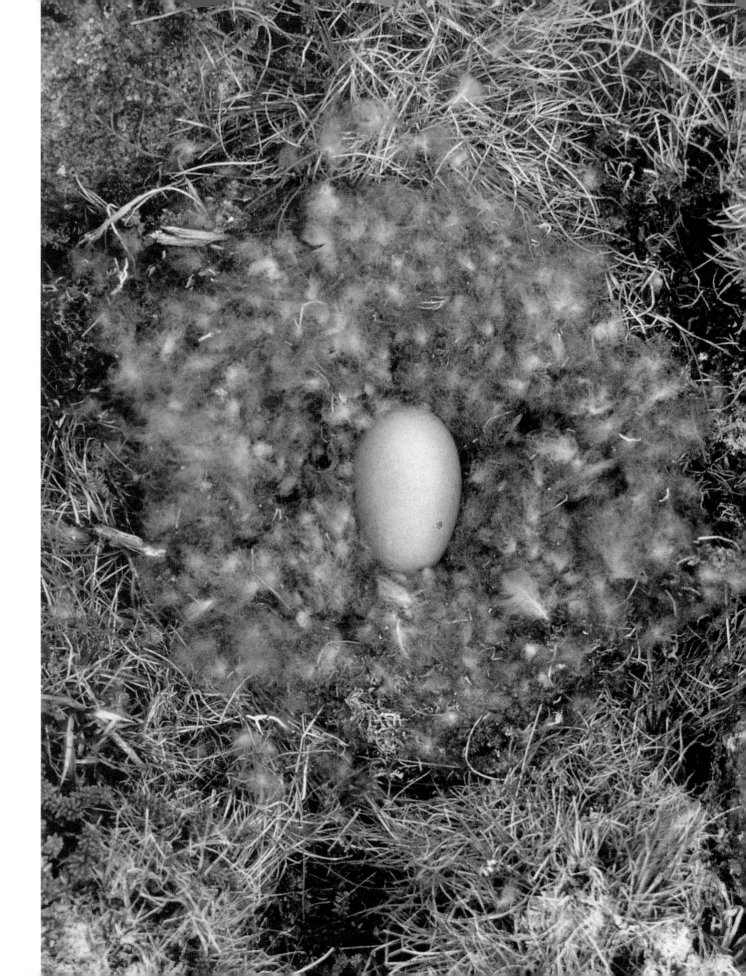

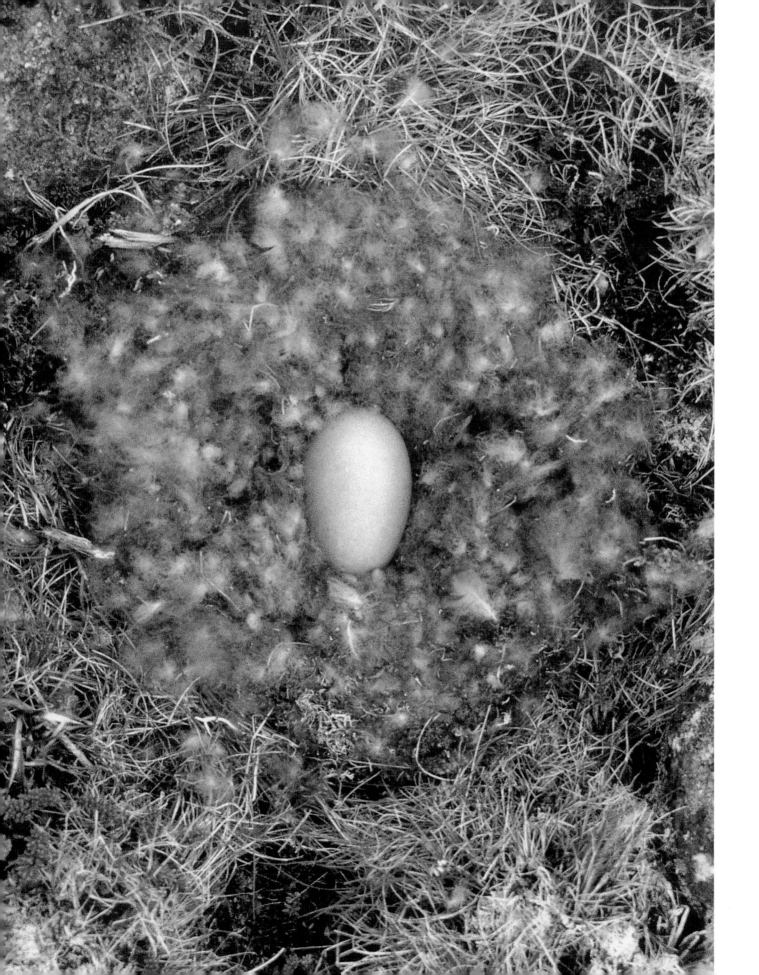

Adam Fuss
British, works in New York, born 1961

From the series *My Ghost*, 2000
Daguerreotype
27.9 x 35.6 cm

Collection of the artist (by courtesy of Cheim and Read, New York)

Adam Fuss recently learnt how to make daguerreotypes, the first photographic process to be announced to the world (in 1839). A daguerreotype image is in the form of a greyish-white deposit on a highly polished silver surface. It can read as either positive or negative, depending on whether the image reflects a dark or light ground. Fuss welcomed the ghostly attributes of the process and also made use of the daguerreotype's unusual response to white, which is often solarized to blue, as in this example. His series *My Ghost* features this image of a swan, floating in a half-seen world, and reflects the melancholy water imagery of one of Fuss's favourite poets, Arseny Tarkovsky.

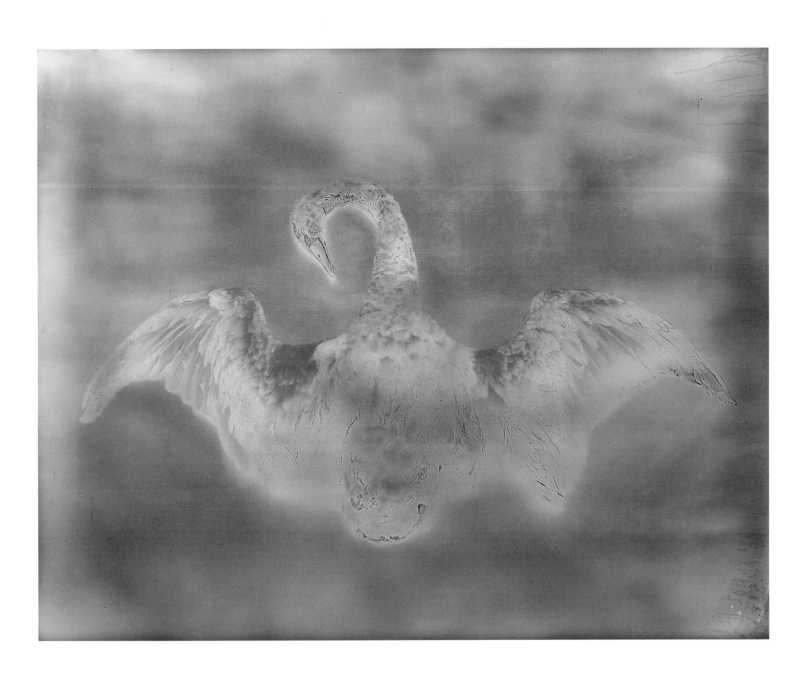

2

Photography was used from the beginning to capture objects – which were better than humans at staying still – but came of age at the Great Exhibition of 1851. This was the first international exhibition to include photographs as exhibits and to be photographed (as well as painted and drawn) – an example is included here. The 1850s also saw the beginning of photography as a tool by which museums copied and shared their collections. This was pioneered by the Minutoli Institute in Silesia and vigorously taken up by the Victoria and Albert Museum. Today's Internet websites continue the same idea. Objects were not only copied. They were arranged, interpreted and enhanced by carefully controlled lighting and by the addition of toning or colour. Photographic illusionism was harnessed to the advertising industry from the 1920s onwards. A superior example of such advertising was commissioned from Man Ray by the Paris Electricity Company. Objects were also interpreted by photographers as the symbols of large historical events. Examples here symbolize the destruction and aftermath of the Second World War. In recent years artists like Joy Gregory have played with, and undermined, photography's supposed objectivity and its role in glamorizing objects.

Artefacts

Joy Gregory
British, born 1959

Hairpin, from the series *Objects of Beauty*, 1993
Kallitype
32 x 32 cm

Given by the Friends of the V&A, 1995

'In the course of our lives,' Joy Gregory has written, 'one of the most important relationships that any of us have is between ourselves and our reflection. Through this relationship we affirm and reaffirm, define and redefine who we are. Much of fashion and beauty photography is silent upon the call for women to cultivate their independence.' Gregory's photographs hold up a mirror to certain 'objects of beauty'. She sometimes includes a measuring tape to imply a cod-anthropological approach. Her use of the 19th-century Kallitype (or Vandyke) process adds a seductive sheen.

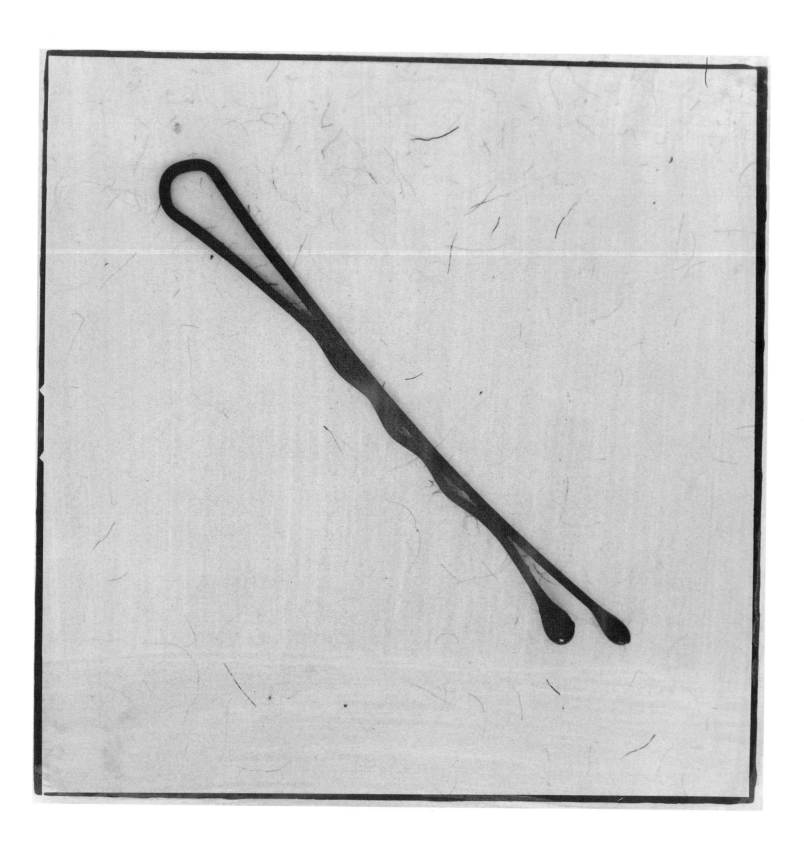

Joy Gregory
British, born 1959

Corset, from the series *Objects of Beauty*, 1993
Kallitype
35 x 35 cm

Given by the Friends of the V&A, 1995

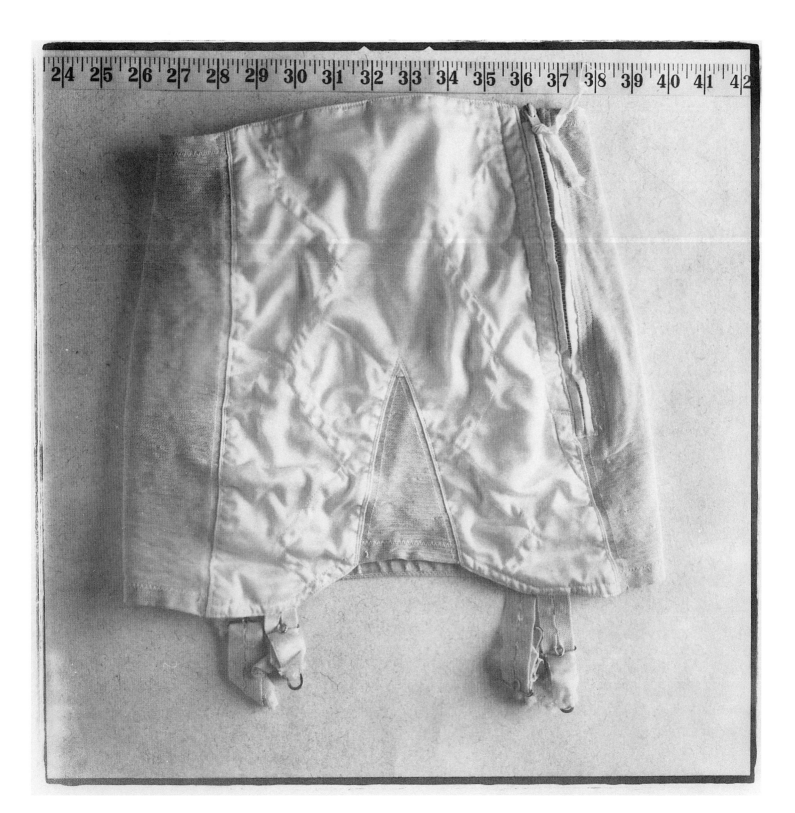

Claude Marie Ferrier
French, 1811–89

or

Friedrich von Martens
German, 1809–75

Disc of Flint Glass by Chance & Co.
Salted paper print from albumen-on-glass negative
Reports by the Juries of the Great Exhibition, vol. II, 1852
17.1 x 14.5 cm

Given by Sir Henry Cole

The Great Exhibition of 1851, held in the Crystal Palace in Hyde Park, was a celebration of progress in art, science and industry. This huge lens, designed to be used in an astronomical telescope, was a technical triumph by Chance & Co. of Birmingham. The lens is a fitting symbol of the first international exhibition at which photographs were shown and the first to be recorded by photography. Photographs were exhibited in the Crystal Palace in the section devoted to 'Philosophical Instruments', alongside telescopes and other new inventions like the electric telegraph.

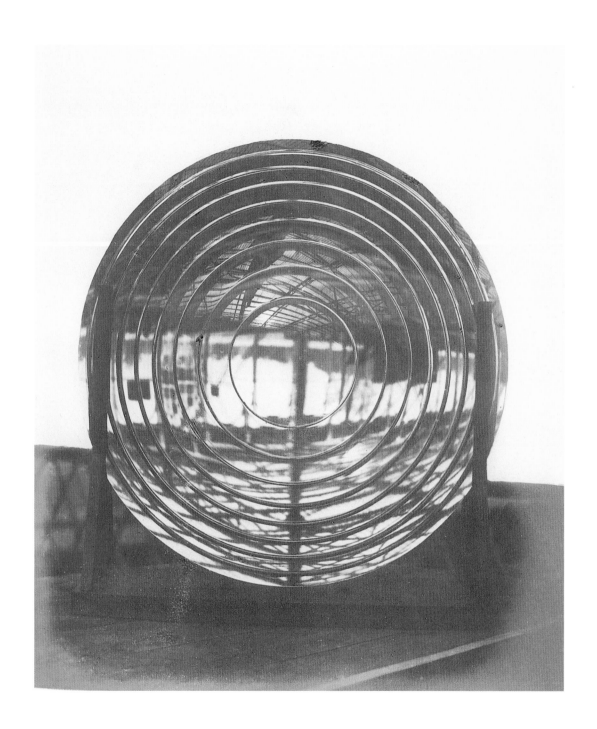

Ludwig Belitski
German, 1830–1902

Trophies of hunting, 16th and 17th centuries
Salted paper print from glass negative
Published in *Models for Craftsmen*, vol. II, 1855
by the Minutolisches Institut, Liegnitz, Silesia
21.7 x 17 cm

Given by Prince Albert, 1855

page 70

Trophy of swords
Salted paper print from glass negative
Published in *Models for Craftsmen*, vol. II, 1855
by the Minutolisches Institut, Liegnitz, Silesia
23 x 19 cm

Given by Prince Albert, 1855

page 71

Venetian-style glass (probably German, 17th and early 18th century)
Salted paper print from glass negative
Published in *Models for Craftsmen*, vol. II, 1855
by the Minutolisches Institut, Liegnitz, Silesia
23 x 18.3 cm

Given by Prince Albert, 1855

The Minutoli collection marks a historical moment. For the first time a collection of models for craftsmen negated the division between fine and applied art. It was structured not only according to materials and techniques, but in terms of history, provenance or use – as shown in this photograph of 34 objects, all associated with hunting. Items include a crossbow, German, Czech and Indian sporting guns (wheel-lock, flintlock and musket, like examples in Gallery 88 of the V&A) and Indian long-guns or Toradars, powder flasks, a hunting bag (or *trousse*), hunting horns, knives and tankards, surmounted by Diana the Huntress.

The seven swords belonged to the Prussian baron Alexander von Minutoli (1806–87), who entered the state service of Liegnitz (Silesia, Poland) as the head of the department of trade policy in 1839. He created a collection of some 4,000 artefacts as a way of improving design and craftsmanship. These objects became the backbone of the Berlin museum of applied arts. The sword hilts, pommels and scabbards are of rare Turkish and Indian craftsmanship, carved in such materials as coral, jade and rock crystal (late 16th century to about 1800). They are shown in silhouette on a dark ground.

Minutoli's model-collection was often sent to schools of the applied arts, but the objects suffered from this treatment. Thus Minutoli commissioned photographic reproductions to circulate instead. The first trial with daguerreotypes failed, because these too, being relatively fragile, also suffered from frequent moving. In 1853 Minutoli engaged the Liegnitz photographer Ludwig Belitski for photographic reproductions on paper. With Minutoli's large commission (seven folio volumes with 663 plates) he earned international fame, winning awards in Brussels and Amsterdam in 1855 and 1856. The Venetian-style glass here was photographed in bright sunlight.

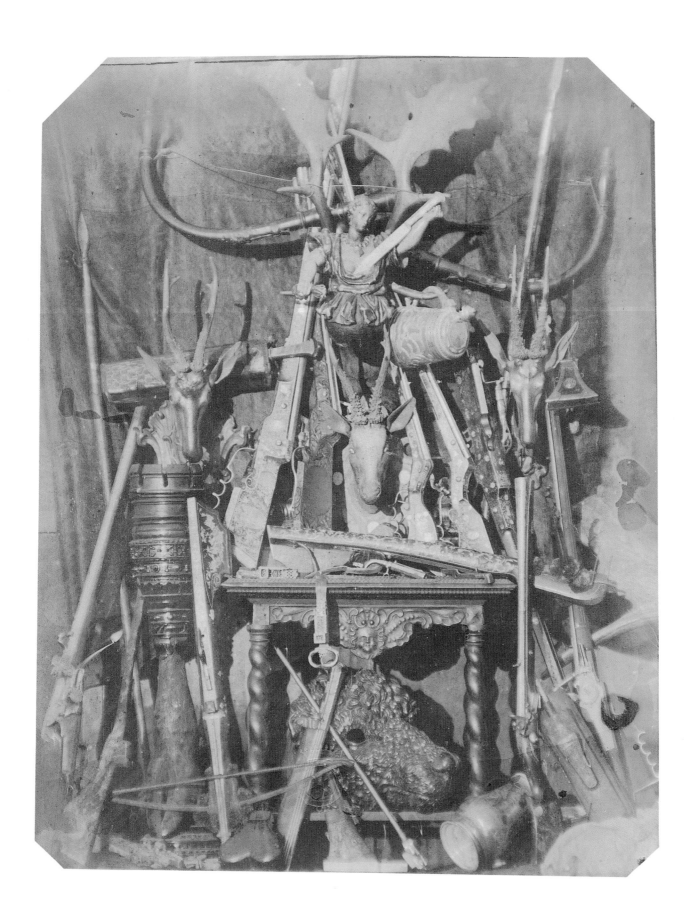

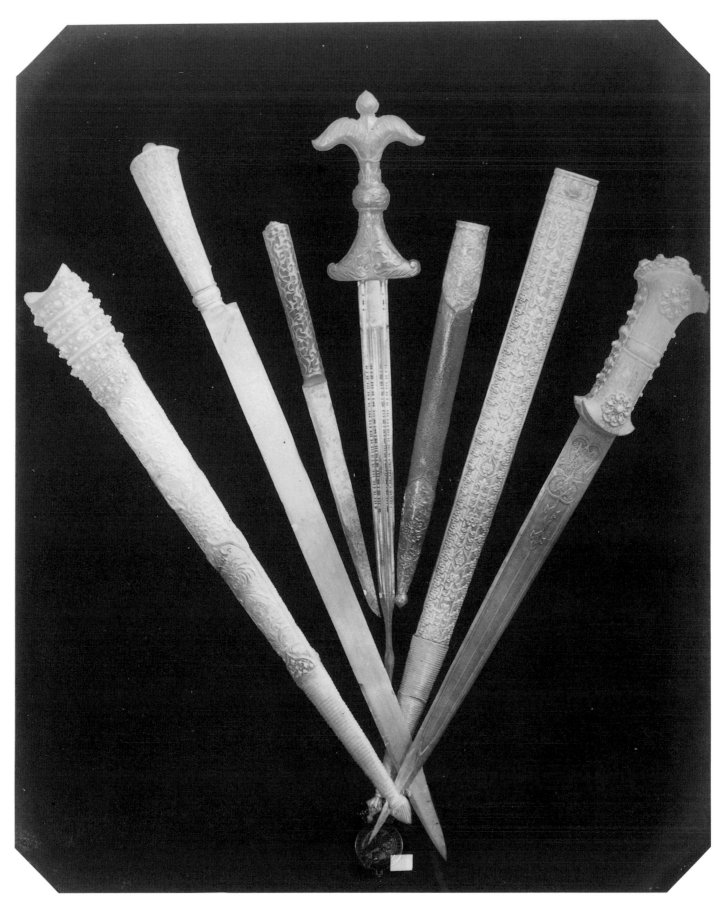

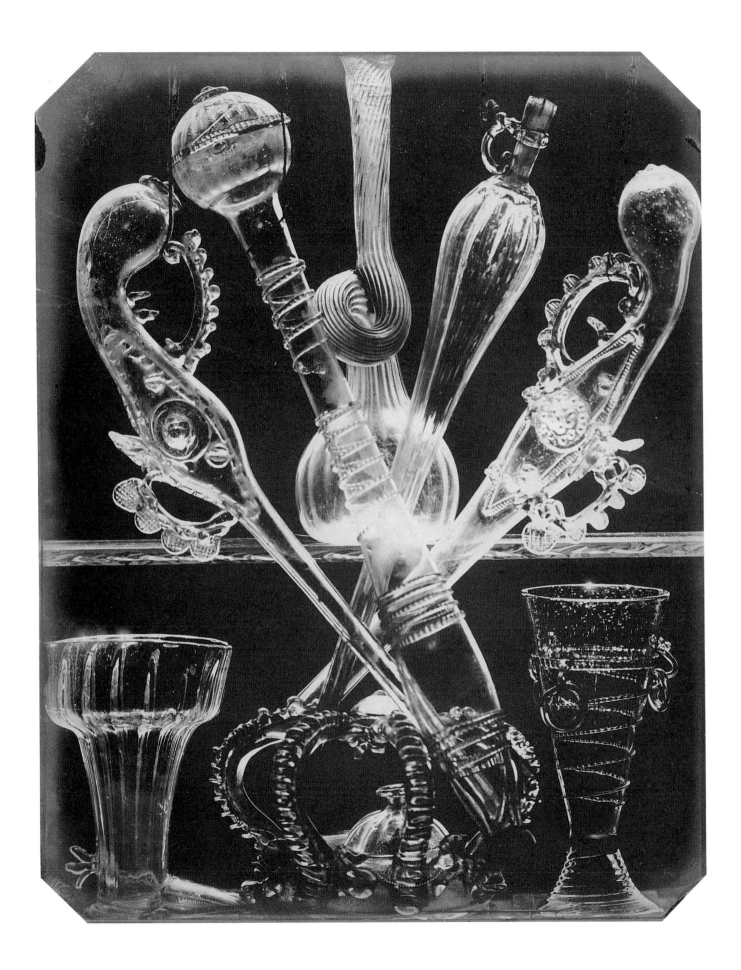

Robert Jefferson Bingham
British, worked in Paris, 1824–70

Still life of antiquities, 1856
Albumen print from glass negative
28 x 17 cm

The works of art owned by Signol, a Parisian collector, are placed – as a still life, not merely as an inventory – before a French or Italian woven silk (19th century) spread in front of a wall in daylight. The works all seem to be Italian: a lead candlestand (16th or 19th century), a majolica jug (Florentine region, *c*.1490–1500), a pilgrim flask (Urbino region, *c*.1540), a stool (16th or 19th century) and a plaster relief with the figure of a standing Christ (early 14th century, circle of Tino da Camaino?). The Signol collection is now in the Musée des Beaux Arts, Tours.

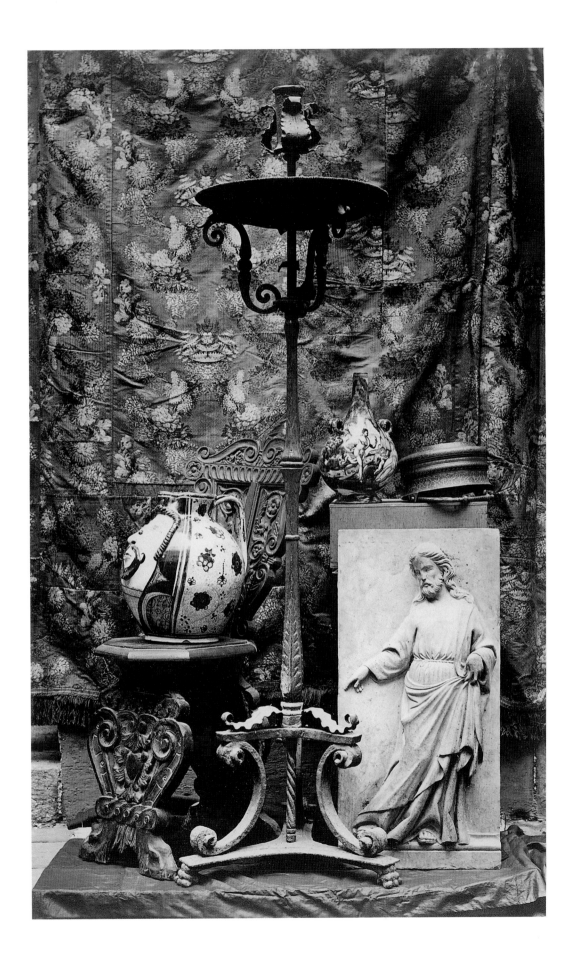

Charles Thurston Thompson
British, 1816–68

or

Robert Jefferson Bingham
British, before 1824–70

Reverse of a majolica plate, Italian, 16th century, probably by
the workshop of Maestro Giorgio di Pietro Andreoli, *c*.1856
Gold-toned albumen-silver print
Diameter: 22.2 cm

The simple floral decoration on the reverse of a plate is realized in
metallic lustre-work, a technique that was first used for majolica in
Italy by Maestro Giorgio (1465–*c*.1553). The fine gold-toned
photograph emphasizes the iridescent qualities of the lustre
decoration. It is not clear who took the photograph. Thompson was
the first official photographer at the South Kensington Museum, but
since the plate cannot be identified with any of the many works by
Maestro Giorgio in the V&A collection (examples are in Gallery 135),
this photograph may be the work of his teacher Robert Bingham.

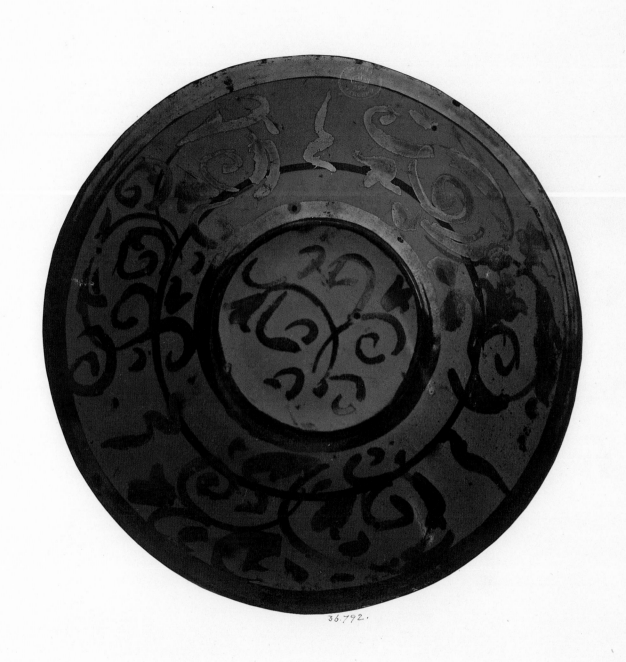

36.792.

T. R. Williams
British, 1825–71

Articles of Vertu, early 1850s
Stereoscopic daguerreotype
17.5 x 8.3 cm

This is one of T. R. Williams's earliest images and important evidence of his dedication to stereoscopy. The precious objects photographed are those that an educated Victorian gentleman would arguably associate with the cultivation and enjoyment of science and art. Photography epitomized the marriage of art and science; this image emphasizes the relationship. The stereoscopic viewer in the image was developed by Sir David Brewster in 1848–49, manufactured in 1850 by Duboscq and Soleil (in Paris) and brought to England for the Great Exhibition, where it became a great success. Brewster also wrote the first manual on stereoscopy, in which these photographs were advertised. The reflection in the bell jar clearly shows the glass roof of the photographer's studio, which maximized the natural light necessary for daguerreotype exposures.

Brian May and Elena Vidal

T. R. Williams
British, 1825–71

Mortality, early 1850s
Stereoscopic daguerreotype
17.5 x 8.2 cm

This image consciously echoes an ancient theme, *Vanitas* (or 'Emptiness'), which consumed 17th-century Dutch and Flemish painters and underlines T. R. Williams's dedication to the artistic aspect of his subjects. He was evidently well versed in the iconography of this genre. All the objects in the arrangement are symbols. An open book represents knowledge as the only imperishable virtue. The hour-glass, the extinguished lamp and the skull all call to mind the inexorability of time and our death.

Brian May and Elena Vidal

Joseph Sidebotham
British, active 1850s–70s

Cheque dated 13 April 1858
Inscribed in ink on reverse: 'Photographed by Joseph Sidebotham
May 1858 with a Lerebours lens'
Albumen-silver print from glass negative
9.5 x 18 cm

Sidebotham was a leading amateur photographer in Manchester and a senior partner in the Strines Calico Company. His photographs appeared in the company newspaper. Photography was used to copy designs in the textiles industry from the 1850s onwards and this copy of a bank cheque may be a demonstration of exact copying technique. Equally, Sidebotham may have been trying out a new lens by the Parisian instrument maker N. P. Lerebours. Facsimile photographs such as this alarmed some commentators of the time, who feared that photography would open up new possibilities for fraud.

B
X 35384 **Manchester** April 13th 1858

To the Agent of the Bank of England

Manchester

Pay to Myself or bearer

Twenty Five Pounds St

25 " 0 " 0

signature
L. Mavrojordato

Anonymous

Copy of a photograph of Queen Victoria, 1860s (?)
Albumen-silver print
10.8 x 9 cm

The portrait in this photograph was taken on 14 November 1861, by Charles Clifford, at Windsor Castle. Queen Victoria noted in her Journal that she had 'dressed in evening dress, with diadem & jewels' and was 'photographed for the Queen of Spain by Mr Clifford. He brought me one of hers, taken by him.' The Queen wears mourning for her mother, the Duchess of Kent, who had died on 16 March 1861, but a copy in the Royal Photograph Collection shows her dress coloured purple; if accurate, this image might be one of the last of her wearing a colour, since the Prince Consort died a month later. This image seems to be a trial-proof of a copy of the portrait, preserved for no known reason, and now an object with its own oblique interest.

Frances Dimond, Royal Photograph Collection, Windsor

Anonymous

Front view of a house altar made for Duke Albrecht of Bavaria
in the Treasury of the Rich Chapel in the Royal Palace at Munich
Salted paper print with watercolour, *c.*1875
42.5 x 28.5 cm

It is likely that the altar was made on the occasion of the marriage
of Duke Albrecht V of Bavaria (1528–79) and Anna of Austria
(1528–90) in 1546. The left door is decorated with the Bavarian coat
of arms and the right door with the Austrian coat of arms. The
Bavarian king, Ludwig II (1845–86), wished to encourage
craftsmanship by having fine copies made of items in the royal
collection. Since colour photography became commercially available
only in the early 20th century, the photographs were hand-coloured.
Salted paper, which had a matt surface, was preferred for hand-
painted photographs in the second half of the 19th century.

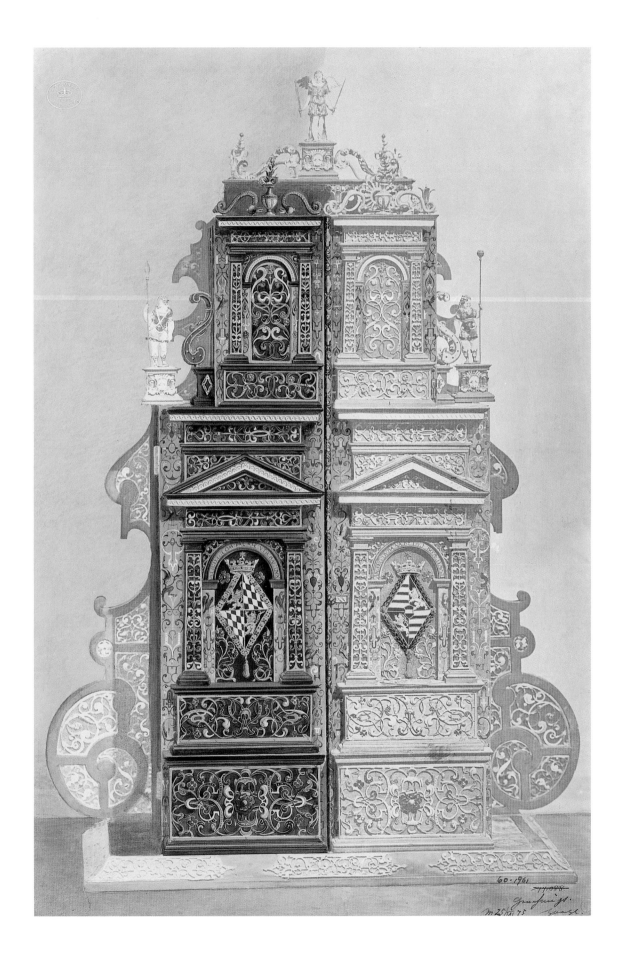

Louis-Emile Durandelle
French, 1839–1917

Published by Delmaet & Durandelle
Couronnement des chéneaux des frontons
(Coping of the gutters above the pediments), Paris Opéra, 1864–67
Albumen-silver print
27 x 38.5 cm

Louis-Emile Durandelle photographed the stages of construction of the New Paris Opéra designed by Charles Garnier and built between 1861 and 1874. Durandelle's series of images show the façade as a whole, the stonemasons at work, and studies of their decorative chisel-work – such as the freshly carved piece seen here – which were then heaved into place. Images such as this convey the scale of the monumental co-ordinated task of building by showing the isolated parts that go to make up the massive whole.

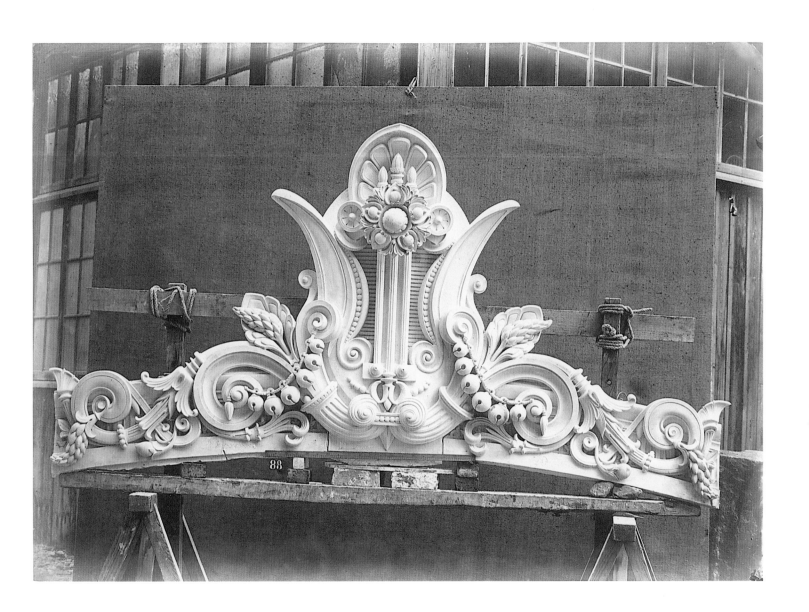

Attributed to
Isobel Agnes Cowper
British, active *c*.1860s–80s

Still Life, *c*.1880
Inscribed in pencil on the mount: 'Still Life'
Albumen-silver print from glass negative
10 x 13.7 cm

This photograph was received in 1880 'from Stores (Mrs Cowper)'. She was the Museum's photographer and this still life may represent her view of such a role, involving record-keeping in quill pen and ink, the production of catalogues and the perusal of suppliers' brochures (from W. Willis & Co., suppliers of platinum paper, among others). The composition is enlivened by a tumbler and carafe, in which the Museum's daylight studio is reflected. The books include the *Catalogue of the British Section, Paris International Exhibition 1867*; *Catalogue to the Duke of Edinburgh's Collection* (1872); the Museum's *Catalogue of Reproductions of Works of Art: Electrotypes, Plaster Casts, Fictile Ivories, Chromolithos, Etchings, Photographs* (1869).

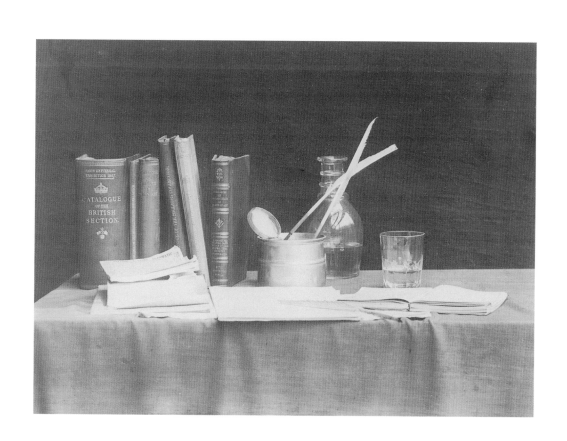

Eugène Atget
French, 1857–1927

Vase by Jean Cornu (1650–1715), Versailles, 1903
Albumen-silver print
21.2 x 16 cm

The V&A bought photographs from Atget because they documented important buildings or, as here, works of decorative art. However, Atget usually had another subject – the mutability of monuments and the passage of time. He photographed a marble urn from the Sun King's reign soon after it had been inscribed with graffiti by tourists (evidently of Anglo-Saxon origin) in July 1903. Less than six months later his photograph had arrived in the V&A Photography Collection, where it would continue to change: starting out as a record, it would become an image in its own right.

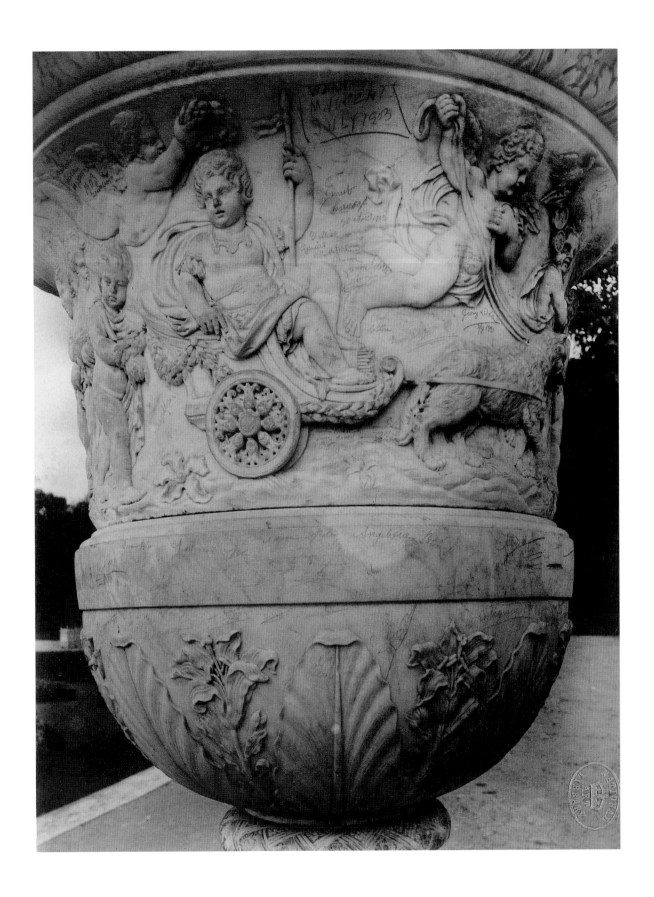

Edward Weston
American, 1886–1958

Excusado, Mexico, 1926
Gelatin-silver print by Cole Weston (1980)
24 x 18.9 cm

Marcel Duchamp exhibited a porcelain urinal, signed R. Mutt, as a 'ready-made' work of art in 1917. Weston photographed his toilet in Mexico without irony. He saw it not only as a perfect example of form following function, but as a beautiful object (not recognized as such because of bourgeois squeamishness). 'Never,' Weston noted in his Daybook, 'did the Greeks reach a more significant consummation to their culture, and it somehow reminded me, in the glory of its chaste convolutions and in its swelling, sweeping forward of finely progressing contours, of the Victory of Samothrace.'

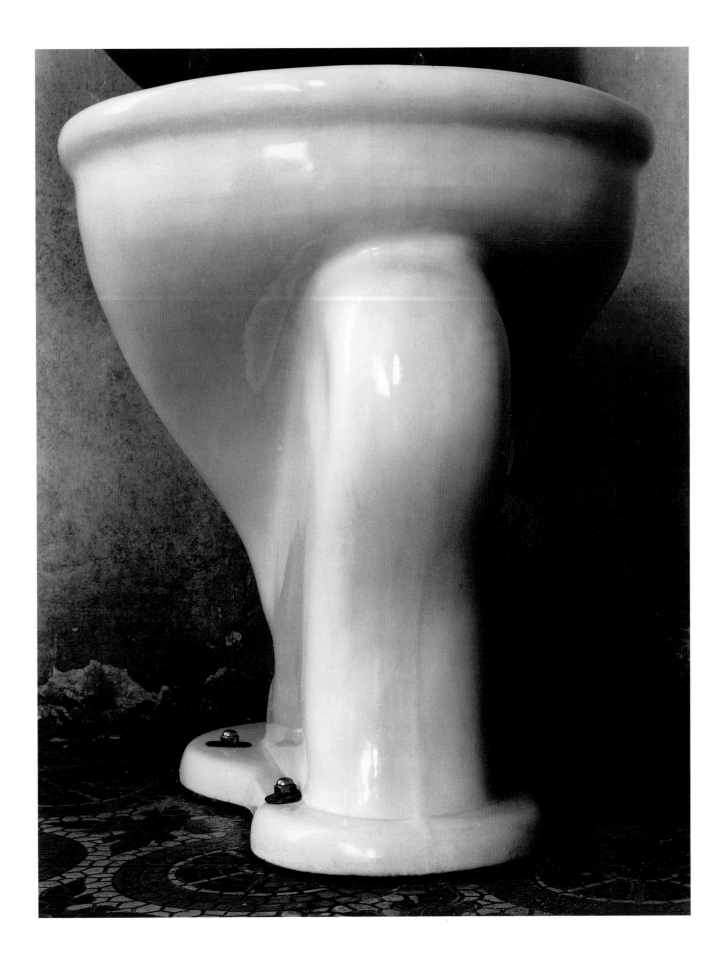

Werner Mantz
German, 1901–83

Bedroom in a villa in Cologne-Marienburg, Germany, 1927
Toned gelatin-silver print
Signed and dated in pencil on the mount
17 x 22.6 cm

Given by Paul F. Walter through the American Friends of the V&A, 2001

Mantz received his first major commission in 1927 from the leading Cologne architect Wilhelm Riphahn, photographing the newly built suburbs of the city. Cologne was in touch with modern art movements, as this interior shows, with its German expressionist landscape (perhaps by Erich Heckel) above the bed. The functional bedside lamps also indicate modernity: in 1927 electricity was still a novelty for most householders in Western Europe. Only 6 per cent of British homes had electricity by 1918; 66 per cent by 1939. Mantz published his photographs in *Bauwelt*, *Die Form* and other magazines.

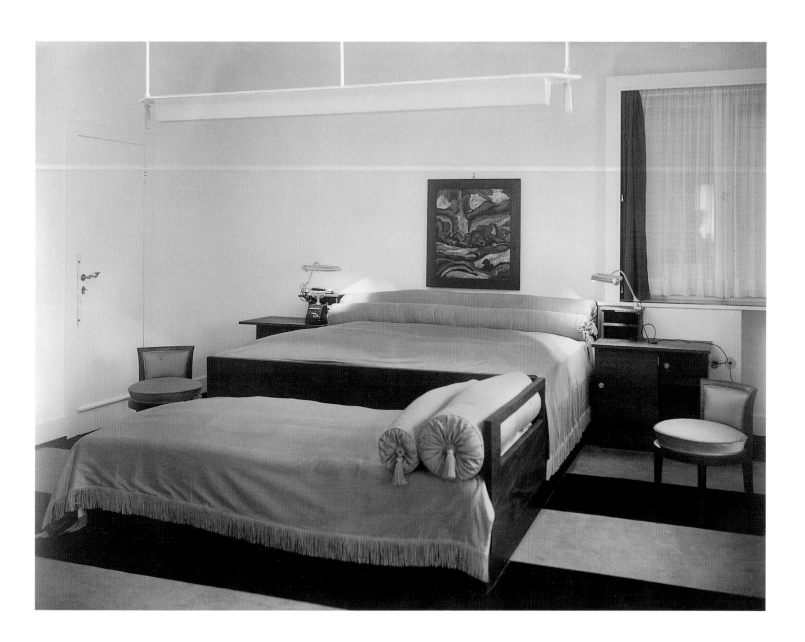

Man Ray

American, 1890–1976

Electricité: Lumière, 1931
Photogravure from a portfolio published in an edition of 500 copies
by the Compagnie Parisienne de Distribution de l'Éléctricité
26.2 x 20.7 cm

Purchased with the generous support of the Friends of the V&A
and the National Art Collections Fund, 2001

page 98

Electricité: Salle à Manger, 1931
Photogravure from a portfolio published in an edition of 500 copies
by the Compagnie Parisienne de Distribution de l'Éléctricité
26.2 x 20.7 cm

Purchased with the generous support of the Friends of the V&A
and the National Art Collections Fund, 2001

page 99

Electricité: Lingerie, 1931
Photogravure from a portfolio published in an edition of 500 copies
by the Compagnie Parisienne de Distribution de l'Éléctricité
26.2 x 20.7 cm

Purchased with the generous support of the Friends of the V&A
and the National Art Collections Fund, 2001

Man Ray is one of the major artists of the 20th century, internationally known for his paintings, sculptures, photographs and films. His most enduring reputation is as a photographer. The portfolio was commissioned by the Paris electricity company in 1931, when Man Ray was at the height of his fame both as a member of the surrealist avant-garde and for his fashion and portrait photography for magazines such as *Vogue*. The idea that fine artists should participate in the applied arts enjoyed particular prestige in the years around 1930.

Most of the images in the portfolio use the 'Rayograph' technique, the photogram process revived by Man Ray in the 1920s. This technique, used from the earliest days of photography, involved laying objects on photographic paper in the darkroom and exposing the composition briefly to light, so that the objects imprinted themselves directly onto the paper. No camera was used. (The more common name is photogram.) Parts of the object not in contact with the paper printed in intermediate tones of grey, which give Rayographs their special subtlety.

Man Ray's subjects in the Electricité portfolio included the neon lighting of central Paris, but were otherwise domestic: an electric fan, toaster, water heater, iron, lamp, oven, light switch and light bulb. He also photographed a torso crossed by ribbons to represent currents of desire.

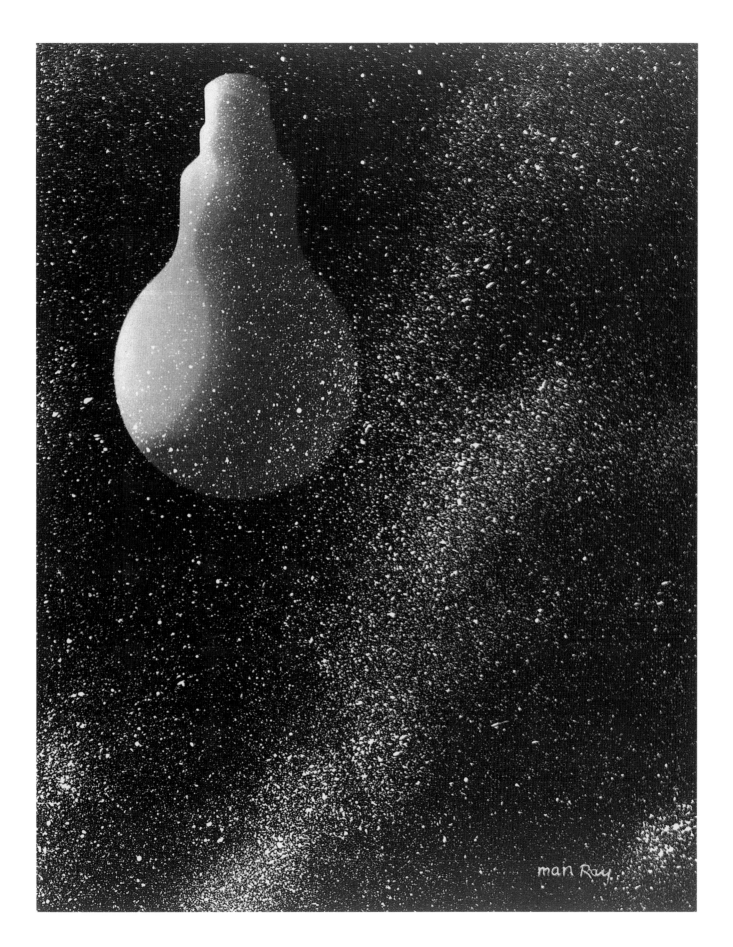

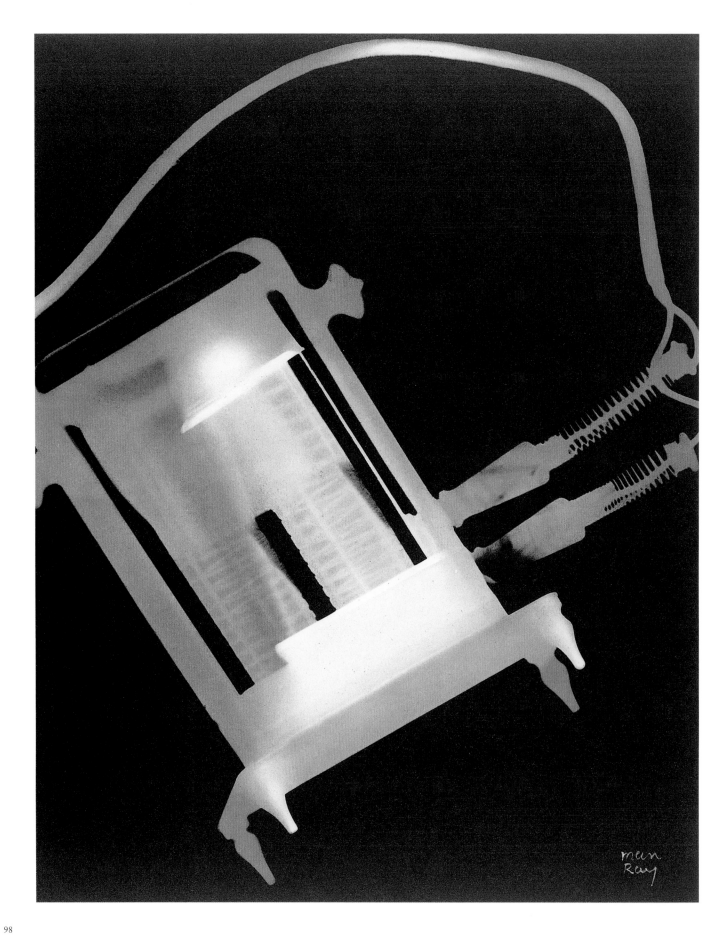

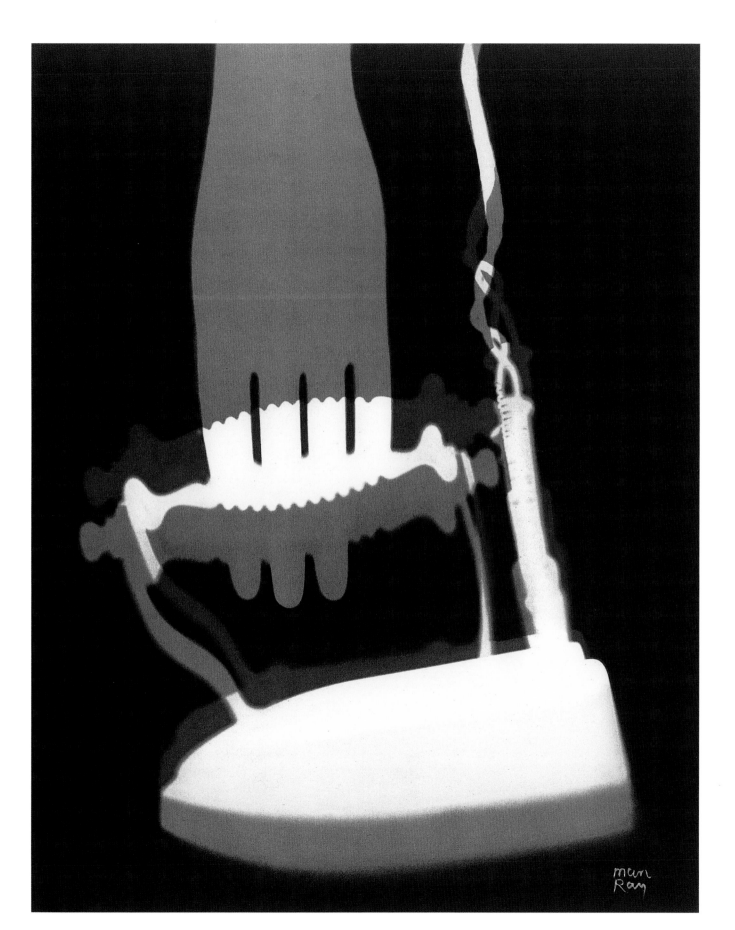

Worsinger/Verne Williams
American, active 1930s

The World Goes Streamline!, *c*.1934
From the album *Shop Windows and Interiors New York*, 1930s
Gelatin-silver print
18.7 x 23.5 cm

This is one of a series of Saks windows celebrating travel – promoting suitcases, cabin trunks and all the paraphernalia for a contemporary voyage. In this case the window also focuses on the futuristic 'streamlined' designs of Norman Bel Geddes (1893–1958), who had worked as a theatre-set designer before he became a pioneer industrial designer, and the display within the display shows models of his aerodynamic automobiles and ship. To the right is a model of the Chrysler Airflow, introduced in 1934 to promote streamlining. The car was not a commercial success, but it is interesting to note that Saks also associated streamlining with women and travel.

Dr Gillian Naylor, Royal College of Art, London

pages 102 and 103

Paper for Pen and Accessories, *c*.1934
From the album *Shop Windows and Interiors New York*, 1930s
Gelatin-silver prints
Both 23.5 x 18.5 cm

The window display, according to Frederick Kiesler in his book *Contemporary Art Applied to the Store and its Display* (1930), was a 'silent loudspeaker…the most successful Esperanto for promoting merchandise'. The small receptacle for cigarettes, keys, etc., is one of the few items illustrated in isolation in these albums, and the reality of the photograph indicates a concern for presentation as well as communication. Although the Thirties are associated with Depression in the United States, these cosmopolitan department stores promoted consumption – modern design could lead the way to regeneration.

Dr Gillian Naylor, Royal College of Art, London

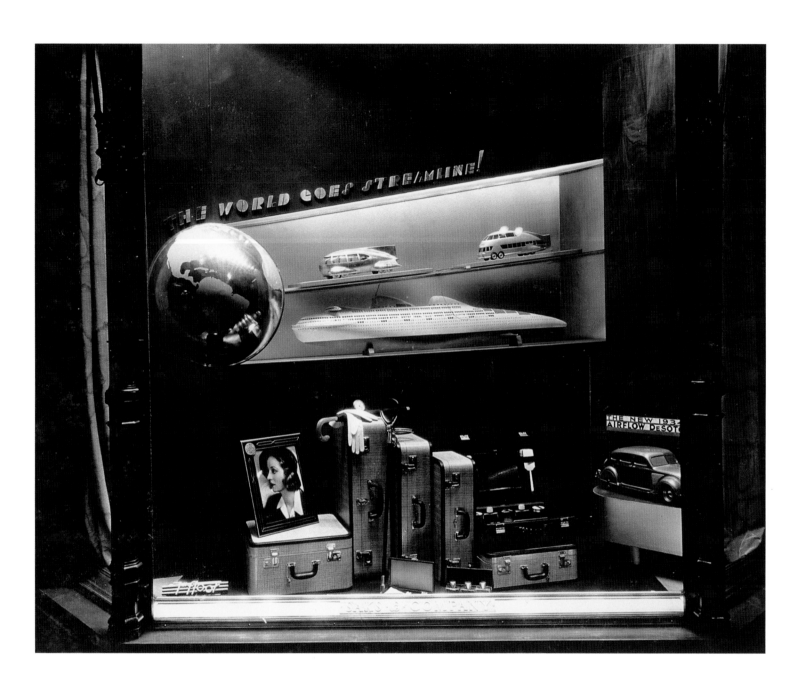

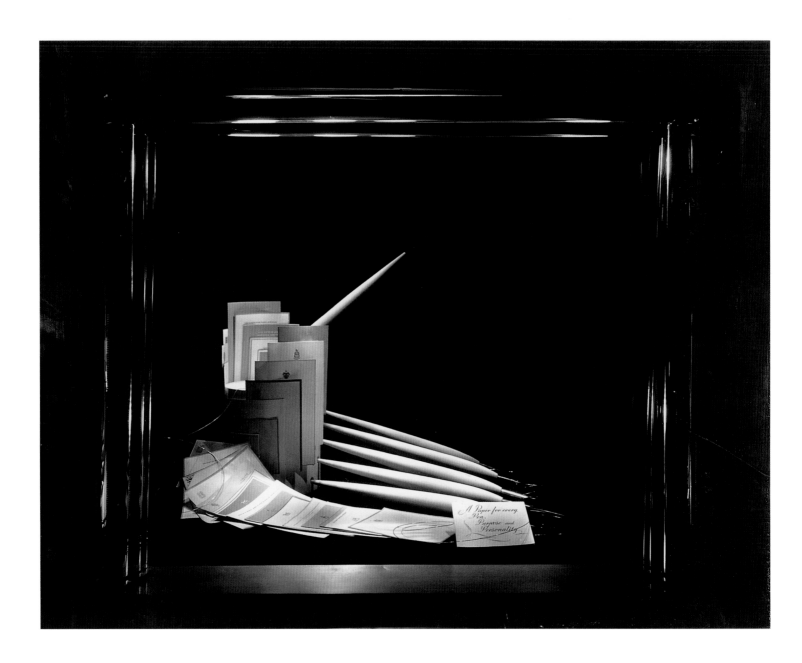

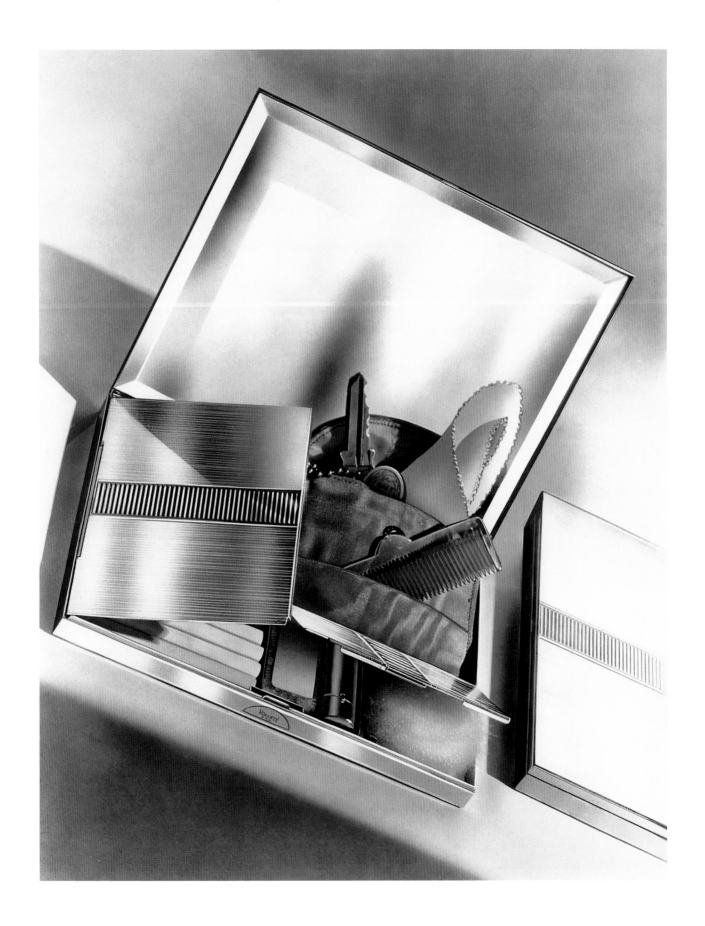

Irving Penn
American, born 1917

Salad ingredients, 1947
Dye-transfer print
49.2 x 38.6 cm

This was first published in *Vogue* (New York) on 1 January 1948 with a text, by Sheila Hibben, that advocated salads as classic as Penn's still life and enumerated the ingredients: lettuces, olive oil, lemon juice, salt crystals, black peppercorns, a pinch of mustard, garlic, 'a malt- or a wine-vinegar or a tarragon vinegar', celery seeds, caraway seeds. ('And nothing – but *nothing* else.') This kind of still life, with easily wilted ingredients, became possible with the short exposures allowed by strobe (electronic flash) lighting, which Penn began to use in 1947. Strobe diffusers are reflected in the silver spoons.

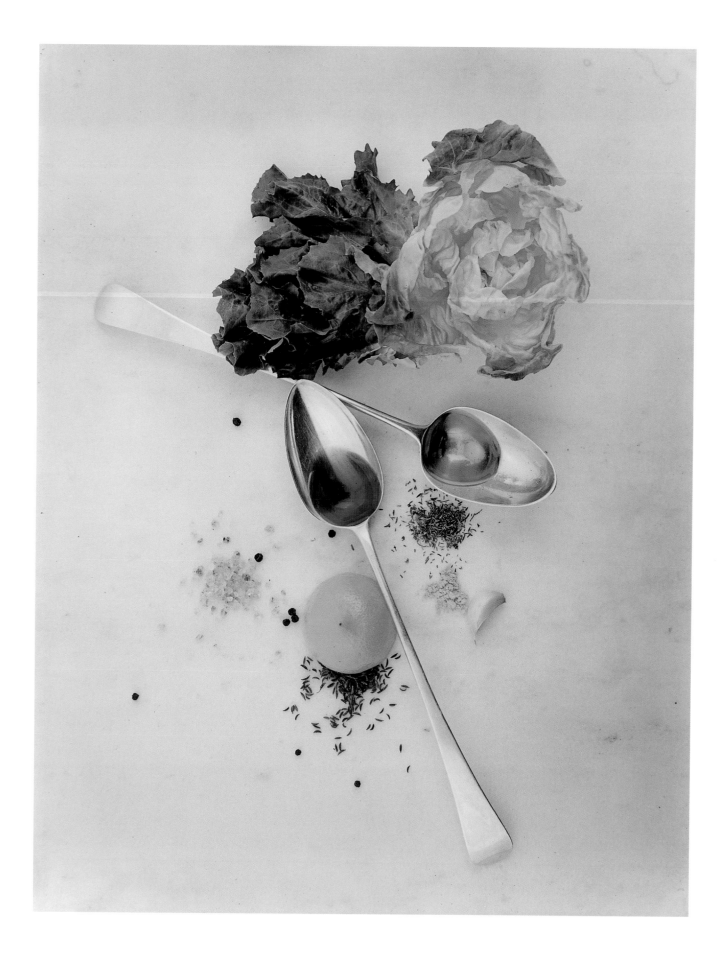

Lester Bookbinder
American, lives in London, born 1929

Handbag, 1983
C-type colour print
36.7 x 29.4 cm

Given by Barbara Lloyd, 2001

Lester Bookbinder trained with the photographer Reuben Samberg in New York City before opening his own studio in 1955. In 1964 he moved to London and became well known for his beauty, fashion and still-life photography. His regular contributions to British *Vogue* in the 1960s were a highlight of the time and proved to be very influential. Since the early 1970s Bookbinder has concentrated on television commercials.

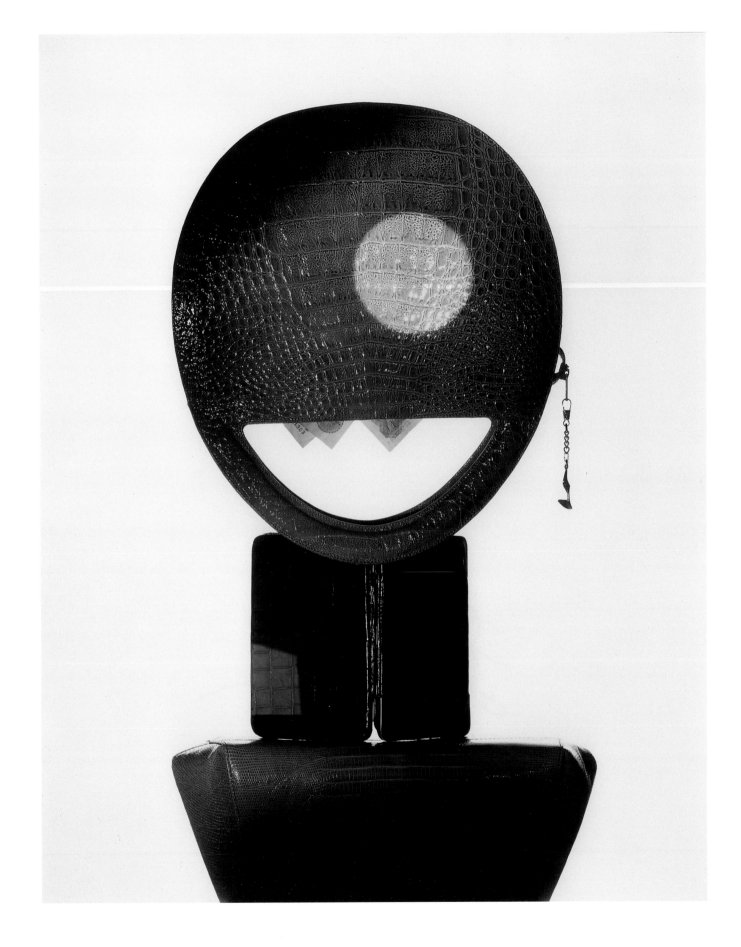

Nigel Henderson
British, 1917–85

The Rat Trap, *c.*1961
Gelatin-silver print (1980)
50.7 x 30.3 cm

Henderson was befriended in the 1930s by Marcel Duchamp, the Dadaist inventor of the 'readymade' work of art. After wartime service in the RAF, Henderson contributed to exhibitions organized by the Independent Group, the British forerunners of Pop Art. He photographed the street life of London's East End in the late 1940s and experimented with photograms, making use of finds from bomb-sites, which he described as 'goldmines of semi-transmuted things, fused, torn, twisted, corroded, eroded'. His dark still life echoes the spiky sculptures of his Independent Group friend Eduardo Paolozzi and recalls his early mentor, Marcel Duchamp.

Nigel Henderson.

Shomei Tomatsu
Japanese, born 1930

Nagasaki, 1961
Gelatin-silver print (2001)
35 x 33 cm

The US dropped an atomic bomb on the Japanese city of Nagasaki on 9 August 1945. In 1960 the Japan Council Against Atomic Bombs asked Shomei Tomatsu to document the aftermath of the explosion. He photographed scarred humans and damaged objects, including a beer bottle distorted by the intense heat into the form of flesh in agony. The series was published in Tomatsu's classic book *Nagasaki* in 1966.

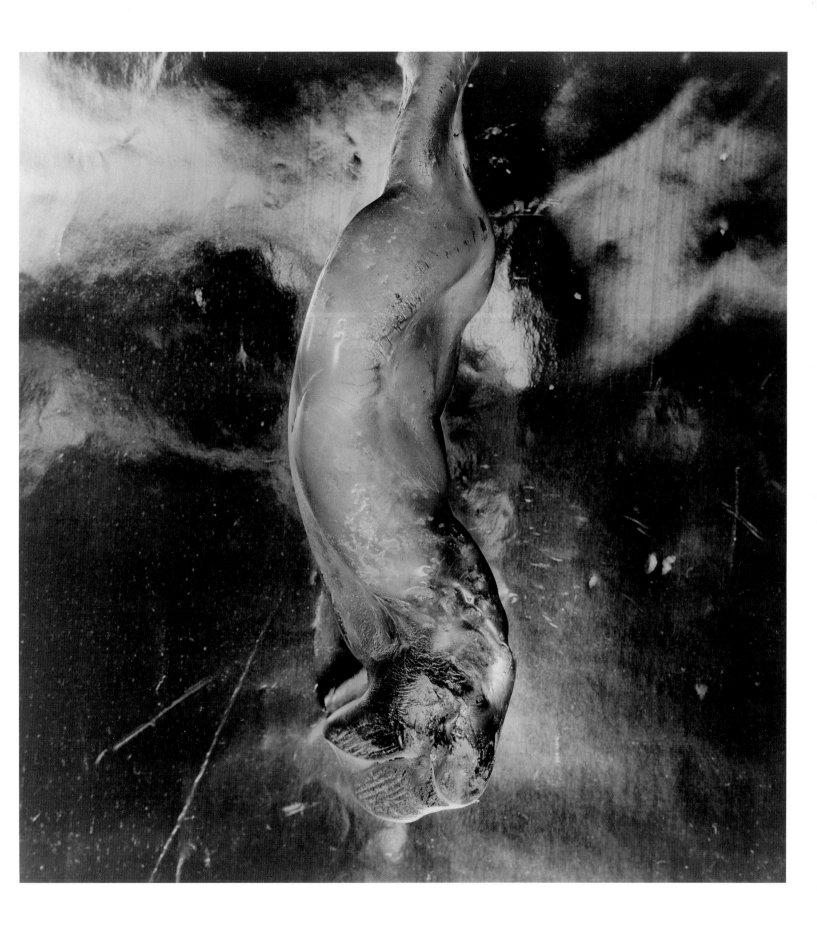

Sheva Fruitman
American

Boot, Paul Smith's R. Newbold clothing line, 1995
Ilfochrome colour print
51 x 41 cm

Purchased with support from Olympus, 1997

Sheva Fruitman works experimentally with a variety of formats – from toy camera to Speed Graphic – and makes cyanotypes and gelatin-silver prints. Paul Smith commissioned a series of photographs from her to illustrate a brochure launching his R. Newbold clothing line in autumn 1995. The line adapted work clothing made by the R. Newbold company (for miners, seamen, road workers and goalkeepers) and re-styled it for the leisurewear market. The colour blue, which used to signify the colour of uniforms and working clothes, is now also the colour of leisurewear.

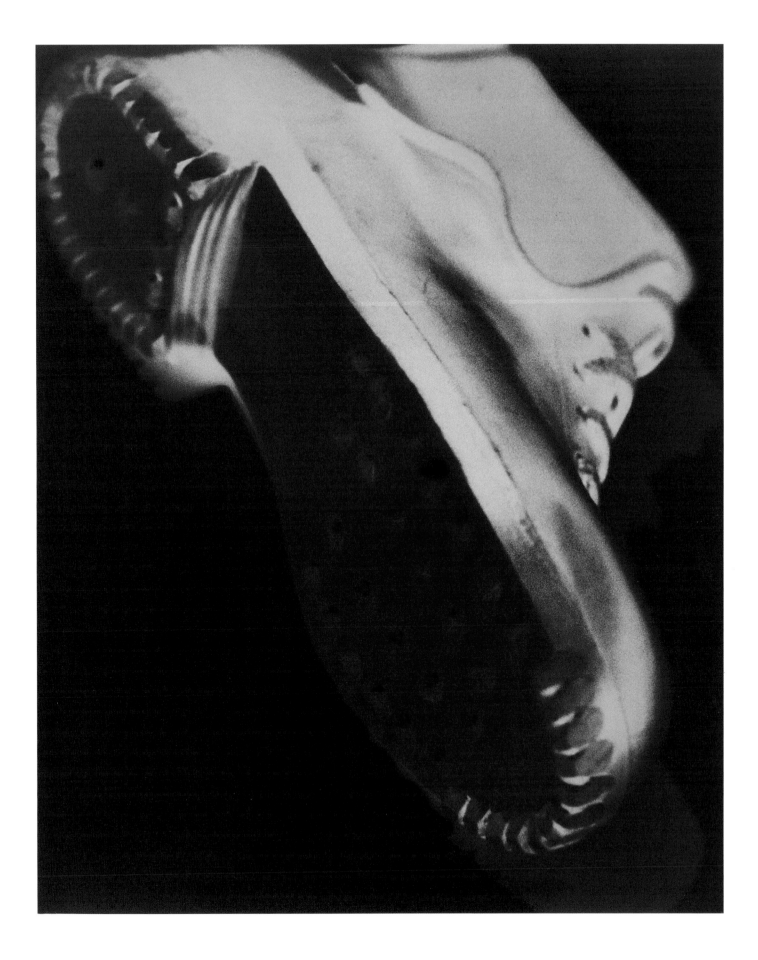

Richard Prince
American, born 1949

Untitled, 1983
C-type colour print
40 x 58.5 cm

Prince initiated rephotography in New York in 1977. He had started to think of the camera as a pair of electronic scissors. He rephotographed four living-room ensembles advertised by the same commercial manufacturer in magazines and made the photographs he had taken into a set of four works. Prince rephotographed biker girls, cowboys and – as here – advertisements for cosmetics. He found that even slight reframings of magazine advertisements could transform them. Above all, he liked what advertisements imagine and how they look: 'They look like they have no history to them – like they showed up all at once.'

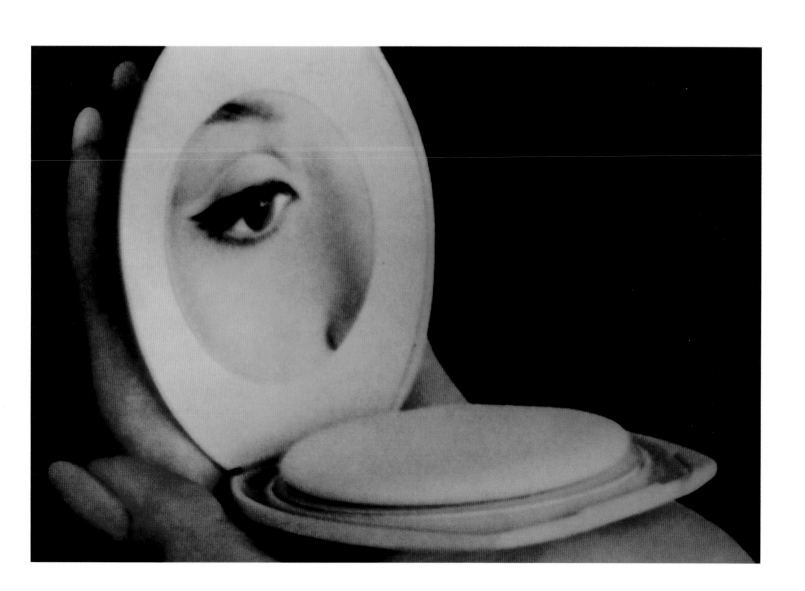

Pedro Meyer
Mexican, born in Spain 1935

Five dollars with Che, 1992
Inkjet print
26 x 62 cm

Given by the artist, 1998

At the top of the bill 'United States of America' obviously reads, within the context of the US, as the name of their country. My picture is about recontextualizing that sentence. AMERICA is the name of an entire continent, which has been sequestered into the name of solely one country. Then you have the dream for which Simón Bolívar fought all his life, and that was the intention of creating the 'United States of America' – in essence, uniting the nations of the Americas. Something for which Che fought as well by going to Bolivia to fight.

Pedro Meyer

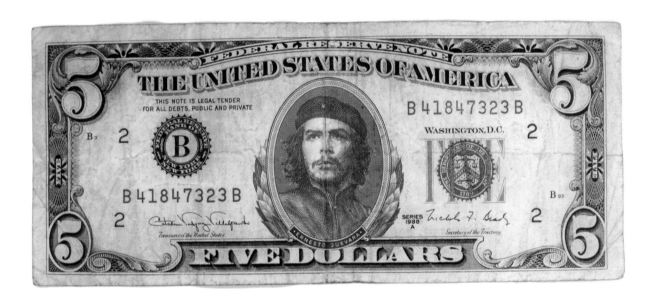

3

The term 'postmodernism' embraces many different, but generally connected, art practices current in the past two and a half decades. One strand of the term refers to the role of artists in engaging with – exposing, questioning and mocking – aspects of mass-media. Another describes the ways in which artists rediscovered and reinterpreted the rich traditions of pre-modern art. A third reflects the role of artists in revising codes of representation relating to, for example, identity, gender and sexuality. A fourth indicates the exploration of multiple viewpoints and open (non-exclusive) meanings. Some of these varieties of postmodernism occur in other parts of the book. All are represented in this section.

Reinventing Things

James Welling
American, born 1951

Untitled, 1981
Platinum palladium print
25.5 x 19.5 cm

In the 1980s James Welling worked freelance, photographing objects for auction-house catalogues. In the same period he was continuing a series of pictures of drapery begun in the late 1970s. By removing any overt object, the series alludes to, yet subverts, pictorial conventions (still life, Old Master drapery studies, etc.). Somewhere between *trompe l'oeil* realism and abstraction, the folds of the cloth both withhold and suggest meaning(s). Welling has written of them as evoking 'a feeling of mortality, of elegy, and also of sails, flags, bunting, of things which in themselves are worth considering, not waiting to reveal, or of something missing, of things although distant still with us, of...interiors and exteriors...'

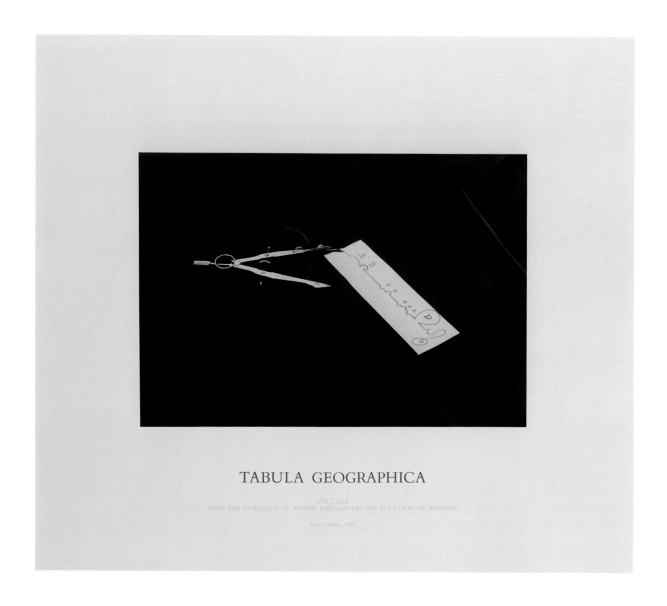

TABULA GEOGRAPHICA

STILL LIFE
WITH THE CURIOSITY OF WIDOW WADMAN ON THE LOCATION OF WOUNDS

Ile de Chillon, 1987

Olivier Richon
Swiss, works in London, born 1956

Tabula Geographica (from the nine-part series *Iconologia*), 1987
C-type colour print with silk-screened title
Sheet: 66.5 x 89 cm; image: 38 x 56 cm

Given by W. Haking Enterprises, 1991

The first line of text gives a Latinate classification of the emblems following Cesare Ripa's *Iconologia* (a source book for artists); the second gives a line from a story as a description; and the third gives a location and a date. These two images are based on the novel *The Life and Opinions of Tristram Shandy, Gentleman* (1759–67) by Laurence Sterne. Shandy aims to recount the amours of his Uncle Toby, but gets side-tracked into describing the structure of the narrative. It is nowadays regarded as the first postmodern text. *Tabula Geographica* shows a diagram that describes the line of the story told so far in the novel. Sterne explains his diagram: '…that except at the curve, marked A. where I took a trip to Navarre, – and the intended curve B. which is a short airing when I was there with the Lady Baussiere and her page…'

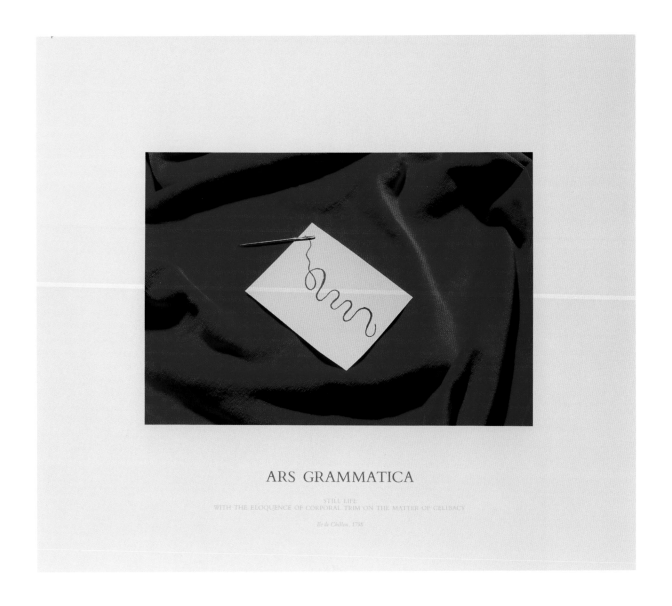

ARS GRAMMATICA

STILL LIFE
WITH THE ELOQUENCE OF CORPORAL TRIM ON THE MATTER OF CELIBACY

Ile de Chillon, 1798

Ars Grammatica (from the nine-part series *Iconologia*), 1987
C-type colour print with silk-screened title
Sheet: 66.5 x 89 cm; image: 38 x 56 cm

Given by W. Haking Enterprises, 1991

Ars Grammatica is based on volume 9, chapter 4 of the same novel. The graphic line in the photograph is printed in the book and introduced by the sentence: 'Whilst a man is free, – cried the corporal, giving a flourish with his stick thus – ', and followed by: 'A thousand of my father's most subtle syllogisms could not have said more for celibacy.' Richon's work stresses the humour of the text and is a playful subversion of its narrative techniques. He reapplies its search for meaning in his photographs, giving a variety of associations but no indication of any final meaning.

Hannah Collins
British, born 1956

Sex, No. 1, 1991
Gelatin-silver prints mounted on cotton
190 x 160 cm

previous pages

Life is very conveniently arranged next to death in Spanish culture, and the passing of life into death is an every-day occurrence and rapidly taken care of. As snails hang in bags leaving little mirrors on the world in their upwards climb to escape, so sea creatures recently hauled from their watery environment climb across stalls in the fish section of the market; both are to be rapidly consumed. Sometimes the whole place seems awash with the liquids of both life and death, leaving me free to explore them without guilt or any other negative association.

Hannah Collins

Helen Chadwick
British, 1953–96

Vanitas, 1985
Installation comprising photocopies on board
and engraved Venetian glass
240 x 290 cm; mirror: 30 x 15 cm

opposite page and following pages

Helen Chadwick used a Canon photocopying machine with a toning device. Photocopying made her independent – a collaboration with a photographer had ended badly – and she liked its combination of reality and abstraction. She used modern office machinery to revisit the past. She was inspired by the Mexican painter Frida Kahlo and by the symbolism of mortality in 17th-century Dutch *Vanitas* paintings. She wrote of this work: 'Art is like crying / an act of self repair / to shed the natural tears / that free us / make us strong…' When installed, the engraved mirror is placed exactly opposite its photocopied counterpart. The viewer stands in the space between them.

Sarah Charlesworth
American, born 1947

Garden of Delight, 1989
Laminated Ilfochrome colour prints with laminated wood frames
104.5 x 155 cm

Sarah Charlesworth uses photographs reproduced in books or magazines. She cuts them from their contexts and rephotographs them against flat colour grounds. The appropriated images are juxtaposed, mimicking the ways in which images function in mass culture and representing – as in this example – such issues as the polarized gender roles currently assigned to male and female. Charlesworth layers her work in complex ways. She contrasts low-grade, coarsely reproduced imagery with brilliant colours, glossy surfaces and lacquer frames. Her tableaux pull us towards them and push us away, repel and seduce. 'The medium is very cold,' Charlesworth has stated, 'the images lure the viewer, but deny the pleasure of the texture of the hand-made.'

4

We think of 'still-life' as a studio genre, but photographers have found memorable, ready-made compositions in interiors or in the street. It is as if we had suddenly turned a corner, glanced through a window, opened a door, or seen something in a shaft of light. Many of the most celebrated of these photographs were made with small cameras such as the Leica, which has exerted a huge influence since its introduction in 1925. Photographers working in this way – from André Kertész and Henri Cartier-Bresson to Lee Friedlander and William Eggleston – give us the illusion of spontaneity. Their images provide us simultaneously with intriguing objects and (so it seems) the best way of seeing them: the most judiciously chosen camera position and framing. Photographers working with view cameras on tripods – from Berenice Abbott to Jem Southam – are also well represented here. If they forgo some of the sense of immediacy captured by their small-camera colleagues, they can use more compositional controls and an abundance of sharply focused and convincing details.

Givens

Jem Southam
British, born 1950

Painting by a man from Chicago on a Painting Holiday,
Mousehole, Cornwall, 1984
C-type colour print
40.8 x 50.5 cm

This is from a series looking at paintings made in the west of Cornwall over a hundred years. The photographs examined the production of the paintings in the landscape and the studio, plus their display in museums, auction houses, offices, homes, pubs, guest houses, shops, waiting rooms. Here the painting is a physical object and a window onto an imaginary realm. The image compares the way a painter constructs an image and the way photographers use apparently more objective strategies to examine the truth. The photograph queries these processes and resonates between the two systems of representation.

Jem Southam

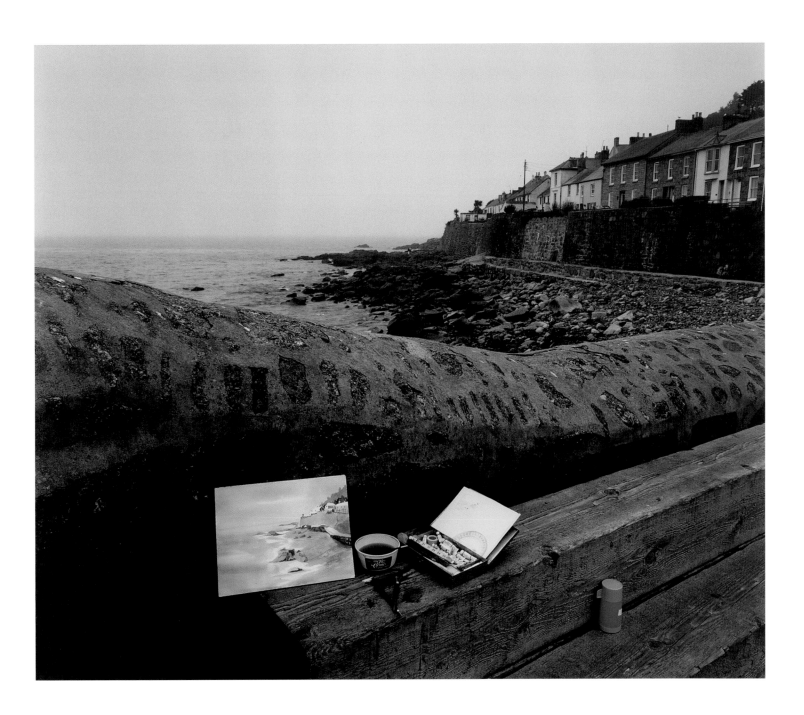

André Kertész
American, born in Hungary, 1894–1985

Chez Mondrian, 1926
Gelatin-silver print (*c*.1970)
25 x 19 cm

Kertész quickly learnt the abstract language of Parisian modernism and was clearly responsive to the pristine geometry that he found in the studio of Piet Mondrian in the rue du Départ. However, there is much more to the photograph than its ordered rectangular planes and the painter's contrasting oval hat. Mondrian felt the lack of a feminine presence in his daily life and chose always to keep a flower in a round vase standing on the hall table at his studio. Friends never saw a living flower in the round vase, but it always held a single artificial tulip. The poet Michel Seuphor recalled that 'An artificial leaf which went with it was painted white by Mondrian to banish entirely any recollection of the green he found so intolerable.'

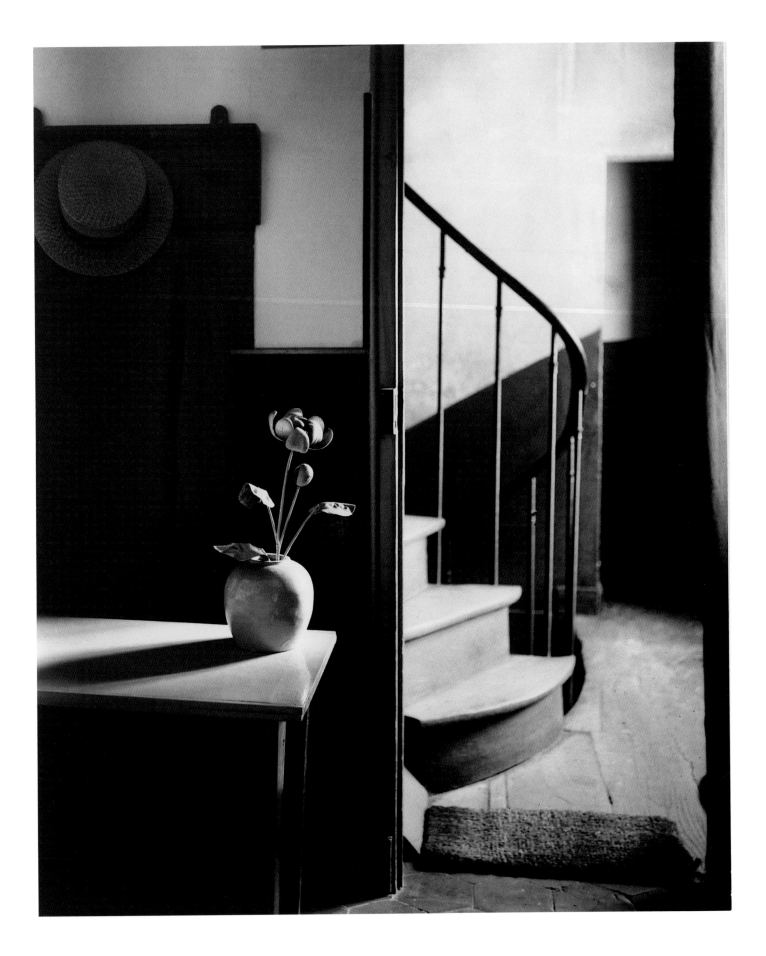

Henri Cartier-Bresson
French, born 1908

Tivoli, 1933
Gelatin-silver print (1972–73)
36 x 24.5 cm

René Char wrote somewhere, *à propos* poetry, that there are those who create and those who discover; they are two completely different worlds. Photography also has two sides to it, and thank goodness. I am only interested in those who discover; I feel a certain solidarity with those who set out in a spirit of discovery; I think there is much more risk involved in this than in trying to create images; and, in the end, reality is more important.

Henri Cartier-Bresson (from a 1989 radio interview, quoted by J.-P. Montier, *Henri Cartier-Bresson: The Artless Art*, 1996, p.110)

Manuel Alvarez Bravo
Mexican, 1902–2002

Un poco alegre y graciosa (Somewhat gay and graceful), 1942
Gelatin-silver print (1974)
17.3 x 24.2 cm

This is from a portfolio of 15 photographs selected and published by Lee Friedlander in 1974. Bravo first exhibited his work alongside Henri Cartier-Bresson in the Palacio de Bellas Artes in Mexico City in 1934. His many admirers include André Breton, Frida Kahlo, Tina Modotti, Diego Rivera, Paul Strand and Edward Weston. Here Bravo makes a playful image from simple ingredients: a floor on the top of a building whitened with a weatherproofing agent, a griddle on which shredded tortillas have been set to dry, a pair of legs, a camisole and shadows.

Berenice Abbott
American, 1898–1991

Hardware store, New York, 1938
Gelatin-silver print (1980)
27 x 34 cm

Berenice Abbott saw herself as a 'photographic historian', selecting subjects through their appeal to her visual sense. Although she became the poet of New York's buildings, streets and trades, she trained her eye in Paris. In the early 1920s she assisted Man Ray and through him met Eugène Atget in 1925. After Atget's death she became the custodian of his negatives and prints and the champion of his vision, which she reapplied to her adopted city of New York, where she lived from 1930 to 1968. This appropriately tack-sharp rendition of a Manhattan hardware store exemplifies Abbott's belief that, whereas painting could address colour and atmosphere, 'the precision, the exactitude of graphic art is the great beauty of the photograph'.

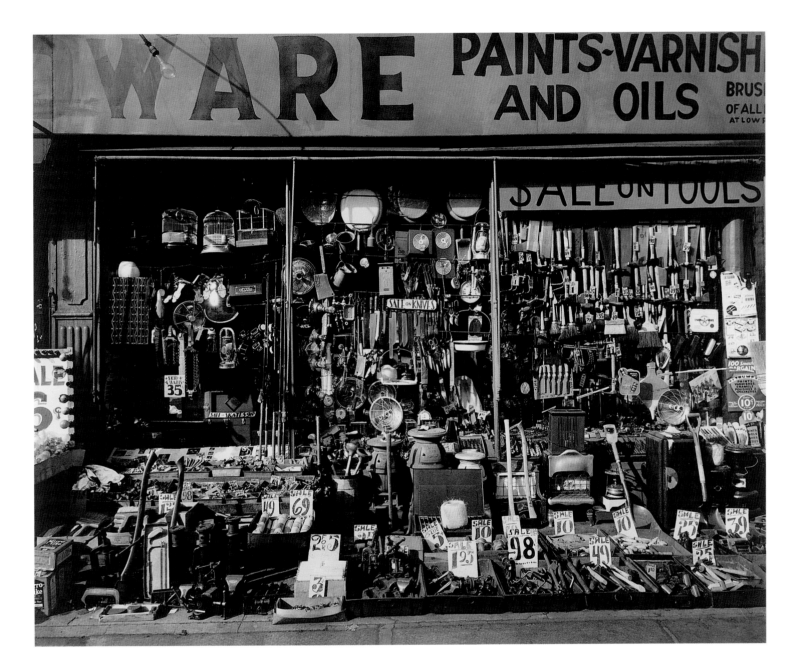

Walker Evans
American, 1903–75

Farmer's kitchen, Hale County, Alabama, 1936
Gelatin-silver print (1960s)
37 x 24.5 cm

Given by Graphics International Ltd, Washington, DC

In 1936 Evans travelled in the American South with his friend, the writer James Agee, who had been assigned to write an article on tenant farmers by *Fortune* magazine; Evans was to be the photographer. What in time emerged from the collaboration was *Let Us Now Praise Famous Men* (1941), a lyric journey to the limits of direct observation and one of the seminal achievements of 20th-century American letters. Evans's photographs of the Burroughs family's tidy kitchen are distilled essences of domesticity and recall Agee's comment that everything in the cabin 'might be licked with the tongue and made scarcely cleaner'.

Jeff L. Rosenheim, Metropolitan Museum of Art, New York

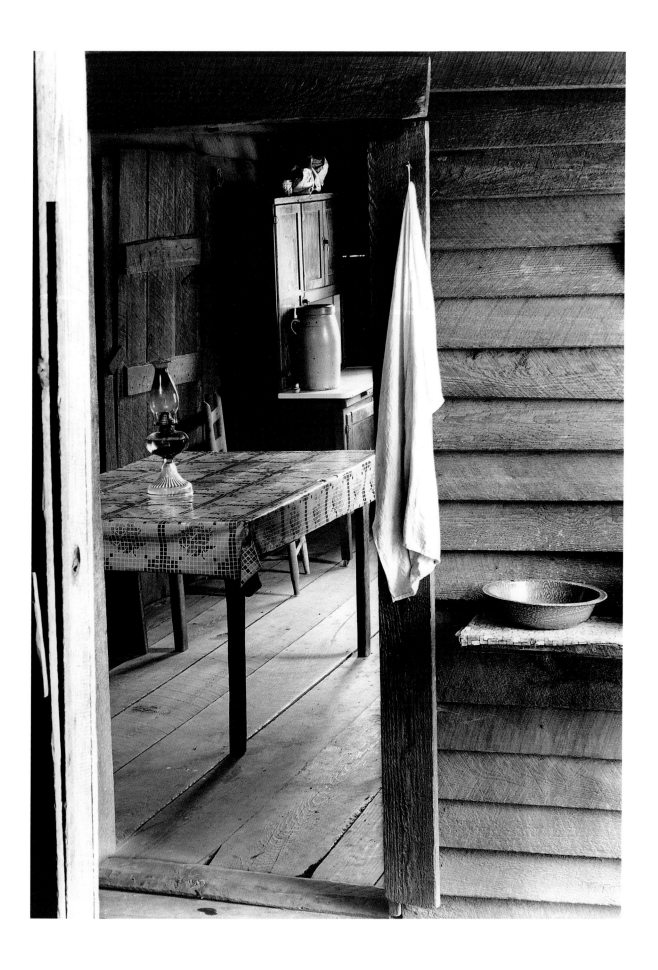

Edwin Smith
British, 1912–71

Cottage Interior, Lightmoor, Shropshire, 1953
Gelatin-silver print
25.4 x 20.4 cm

Given by Olive Cook, 1987

The camera has captured the moment (12.20 p.m. on 19 September 1953) when the midday sun, streaming through the one small window, reveals and accentuates every telling detail of the interior – the unseen cottager's spectacles amid the clutter of plates, utensils and food on the oilcloth-covered table; the bright steel fire-dogs, trivet, tongs, shovel and poker; the handsome hanging oil lamp; the brass candlesticks and the tea caddy on the mantelshelf; the locally made spindle-back chairs. There is little of the 20th century except the photograph of the newly crowned Queen, a copy of which could at that time be seen in nearly every cottage and farmhouse.

Olive Cook, author, wife of Edwin Smith

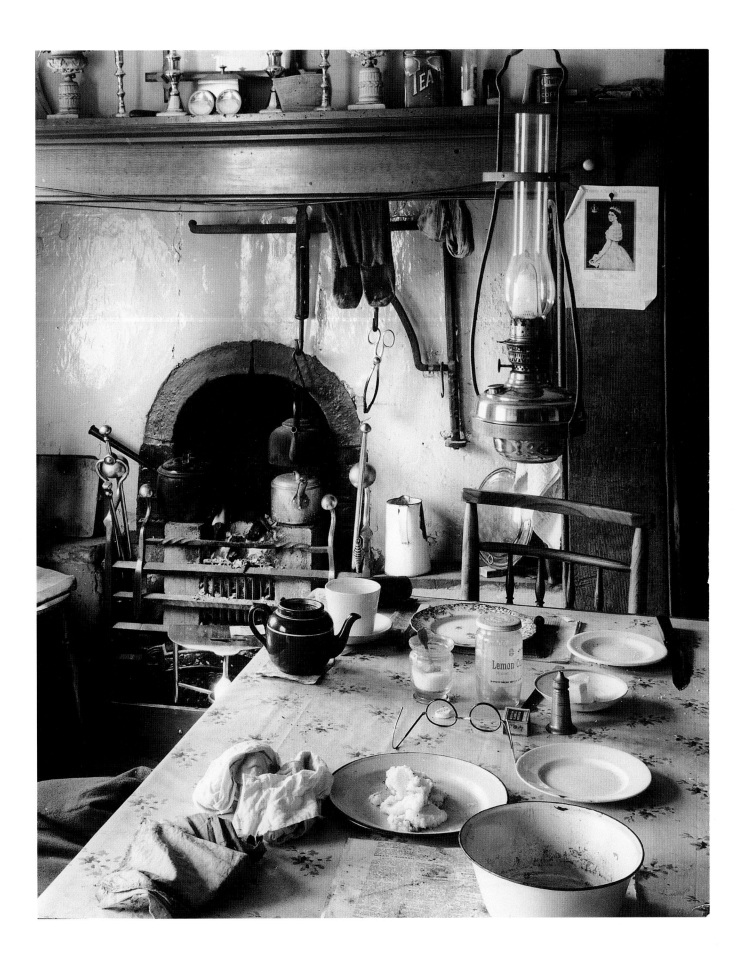

Aaron Siskind
American, 1903–91

Chicago, No. 21, 1949
Gelatin-silver print
49 x 37.5 cm

Given by Robert B. Menschel, 1979

In the 1930s Siskind was a member of New York's Film and Photo League and made outstanding documentary photographs of dance in Harlem. In 1944 he discovered a completely different kind of photography allied to the most exploratory painting of the time. With *The Glove* (1944), photographed from above against wood, he pictured an object that was simultaneously hyper-real and abstract, an intensely real fragment of the world and a mark on paper – like the peeling bark of a tree that he photographed five years later in Chicago. Ten years after that his first book was published, introduced by the art critic Harold Rosenberg, thanks to the support of the abstract expressionist artist Franz Kline and other painter friends.

André Kertész
American, born in Hungary, 1894–1985

Homing ship, 1944
Gelatin-silver print (*c*.1970)
24.8 x 19.8 cm

André Kertész was the brightest of stars in the avant-garde of European photography in the 1920s and early '30s – 'my poetic wellspring', as Cartier-Bresson called him. He accepted an invitation to continue his career in the US in 1936, but found that American photojournalism was run on very different lines. He felt increasingly like a fish out of water – which is perhaps part of the symbolism of this photograph. It is more than a momentarily caught study of a man carrying a model schooner from Conservatory Pond to the Boathouse in Central Park. It is surely significant that Kertész made the photograph as the Second World War was coming to an end – and that he often reproduced it under the title *Homing Ship*.

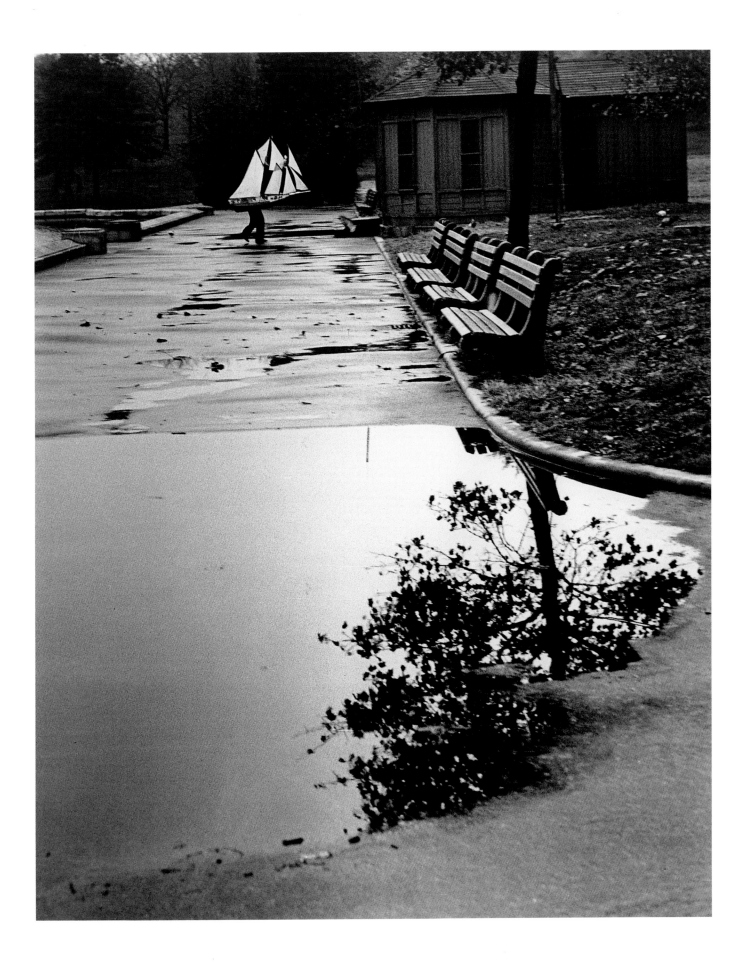

Lee Friedlander
American, born 1934

Knoxville, Tennessee, 1971
From *Portfolio*, introduced by Walker Evans, 1973
Gelatin-silver print
16.5 x 25 cm

Given by the Gordon Fraser Charitable Trust, 1980

Lee Friedlander takes one of photography's enduring themes, which has challenged and inspired photographers since the 1850s, and gives it his inimitable signature. In his range-finder, however, clouds become something else – transformed into components of a virtual collage. Often, in the 1960s, Friedlander's inventive ability to see cities as collages drew his vision close to the Robert Rauschenberg of the silk-screened 'combine' paintings. Here he sees an event that perhaps no one else ever saw, let alone photographed. As Walker Evans remarked, Friedlander 'uses photography with deadly aim to reflect and record only his very special, personal vision of his world'.

Jonathan Bayer

American, British resident, born 1936

Eating Utensils, Cell, B Block, HMP Wormwood Scrubs,
London, 1977
Gelatin-silver print
16.5 x 24.5 cm

Cell interior, B Block, HMP Wormwood Scrubs, London, 1977
Gelatin-silver print
24.5 x 17 cm

These photographs are from an extensive study of English prisons
undertaken by Jonathan Bayer in the 1970s with two sociologists, Dr
Roy King and Dr Rodney Morgan. Their study aimed to examine the
ways in which prison buildings and penal regimes are experienced
practically and at symbolic levels, thus opening up the prison system
to a more public examination. Bayer's photographs encourage
thoughts about space, routine, order and context.

Dorothy Bohm
British, born 1924

In Jason Wason's studio, Cornwall, May 1995
C-type colour print
39.5 x 27 cm

Given by the artist

Jason Wason's studio was filled with marvellously crafted large pots. Some were even suspended from the ceiling. A scene by the window attracted my attention. It exuded a wonderful sense of harmony. The summer light coming through the open window was soft and glowing. The rough painted walls against which the objects were placed seemed such a natural backdrop. The plain window was topped by an intricate frieze and the only rich colour was provided by strips of crunched up papers hanging from the ceiling. Jason had put them there to prevent rain coming through the ceiling.

Dorothy Bohm

William Eggleston
American, born 1937

Untitled (blue vase) from *Southern Suite*, published 1981
Dye-transfer print
25.2 x 38.5 cm

Eggleston changed the course of colour photography in modern times by translating the intense, super-real quality of colour transparencies into the saturated hues of dye-transfer prints. His subtle choices of camera positions also loosened up photographers' ideas about viewpoint. When beginning his experiments with dye-transfer printing, Eggleston was thrilled by the idea of capturing particular colours, as if for the first time: 'I realized in the middle of this traditional table was this arresting purple-blue,' he recalled later, 'and it represented like a missing primary pigment in a box of colours for me.'

5

Objects have traditionally been used as attributes of portraiture. Photographers took over the idea from painters and have used it extensively in attempting to illuminate the occupation, interests, social position, personality or perhaps even the spirit of their sitters. The tradition has many entertaining moments, like Michael Bennett's well-loved *Uncle Cyril Arriving for Tea*, and such experimental images as the portrait with a photogram border by Oscar Gustave Rejlander and Julia Margaret Cameron in this section. Mrs Cameron transformed the portrait in this picture: perhaps she added the border of ferns to suggest the 'natural' innocence and purity of her sitter. Sometimes a photographer discovers an attribute that is so powerful, memorable and easy to copy that it assumes a life of its own. This occurred in 1963 when Lewis Morley had to find a way to photograph Christine Keeler nude. His clever solution respected both her modesty and her contract. Thanks to the generosity of Lewis Morley and the Knaus family, the photograph, the contact sheet and the celebrated chair itself are now part of the V&A collections. They are all illustrated here – plus a portrait of Dame Edna Everage, and a text by Dame Edna in her inimitable style.

People and Things

Nobuyoshi Araki
Japanese, born 1940

Geisha with Melon
Ilfochrome colour print
41 x 32.5 cm

Bought from the Sir Cecil Beaton Fund, 2001

A young girl crouches in a faintly submissive way, sucking out the juice from a piece of ripe watermelon with provocative intensity. The fruit lies open by her side like a split vulva. Araki is spellbound by this libidinous world, and he is not alone. When he walks down the streets of Shinjuku, that neon 'entertainment district', he is followed by admiring hangers-on. The late British artist Helen Chadwick owned this copy of *Geisha with Melon* and celebrated this kind of beauty in sexual imagery too. Araki is the Toulouse-Lautrec of Japan, the artist as modern-day flâneur, intoxicated by his softly illicit world.

Simon Grant, editor, *Tate Magazine*

Robert Crawshay
British, 1817–79

A Slow Market: Harriette, 1868
Albumen-silver print from wet collodion negative
24.5 x 29 cm

Given by Edmund Esdaile, 1984

Robert Crawshay was the fourth 'Iron King' of the Cyfarthfa Iron Works, Merthyr Tydfil. In 1867 he became a member of the (Royal) Photographic Society. *A Slow Market* was probably taken during spring 1868. It is beautifully made and carefully observed; the tear in the tablecloth echoes the open mouth of the nearest salmon. The photograph combines the popular genre motif of fisherfolk with a tradition of still life, and a Victorian predilection for dressing up. Beneath the shawls and skirts is Crawshay's daughter, Rose Harriette. She wrote in her diary (23 March 1868): 'Papa came in with the ugliest, dirtiest, nastiest old straw bonnet that ever existed and a cap (thank goodness that was clean) for me to be photographed in as a fish woman which lasted till lunch time.'

Jane Fletcher, National Museum of Photography, Film and Television, Bradford

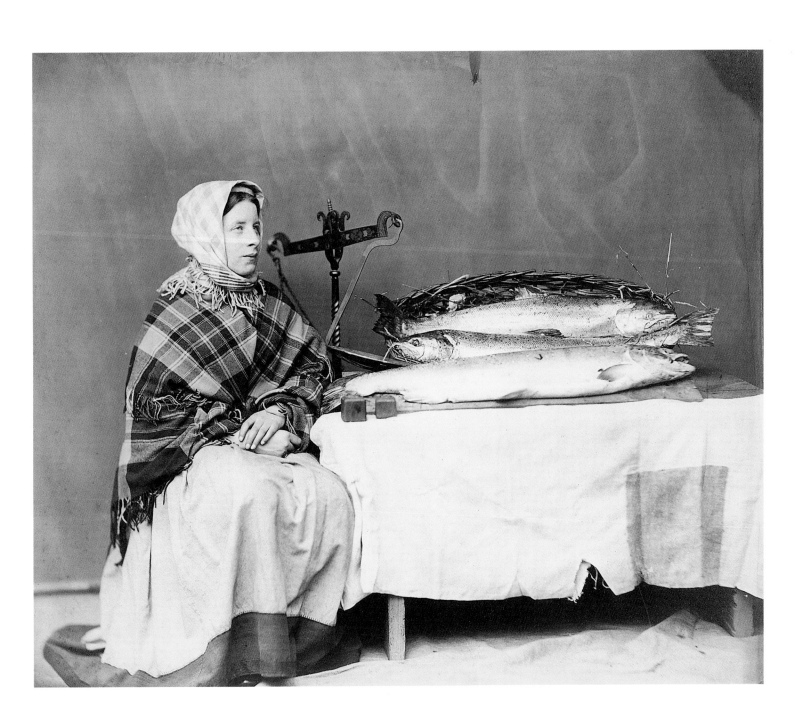

Julia Margaret Cameron
British, 1815–79

and

Oscar Gustave Rejlander
British, born in Sweden, 1813–75

Kate Dore with frame of plant forms, *c.*1862
Albumen-silver print (composite)
Irregular: 19.6 x 15 cm

Recent research by Joanne Lukitsh has made it clear that Cameron began to work with photography and photographers before taking up a camera herself in January 1864. She commissioned portrait photographs from O. G. Rejlander, one of her most creative contemporaries. Cameron then used the photogram technique to add a frame of ferns. She placed the plants between the wet collodion glass negative and the albumen printing paper and printed the ensemble out in sunlight. By these means the portrait became a unique decorative object – but perhaps the delicate ferns also symbolize the spirit of the young woman who poses among other, conventionally photographed, foliage.

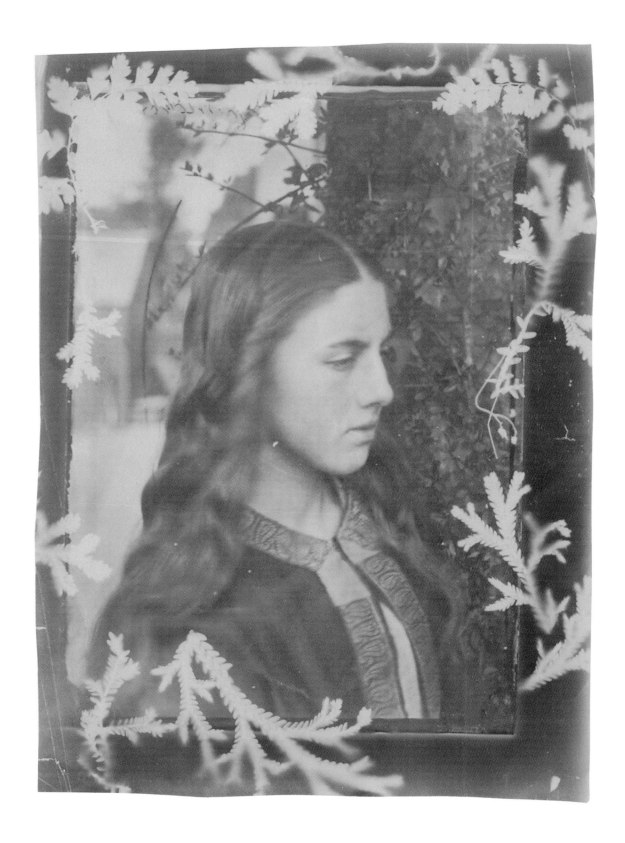

Eugène Atget
French, 1857–1927

Marchand Abat/Jars (Street Trader)
Gelatin-silver print by Berenice Abbott (1956)
20.8 x 16.6 cm

Atget was principally a photographer of objects and places. He took no portraits *per se*, but he did contribute to a long tradition of portraying street traders, whose roles are defined by the objects they sell. Here he photographed a pedlar selling lampshades, using the unusually short (wide-angle) lens with which he generally photographed streets. The consequence is a portrait of a trader both encircled and illuminated by his wares.

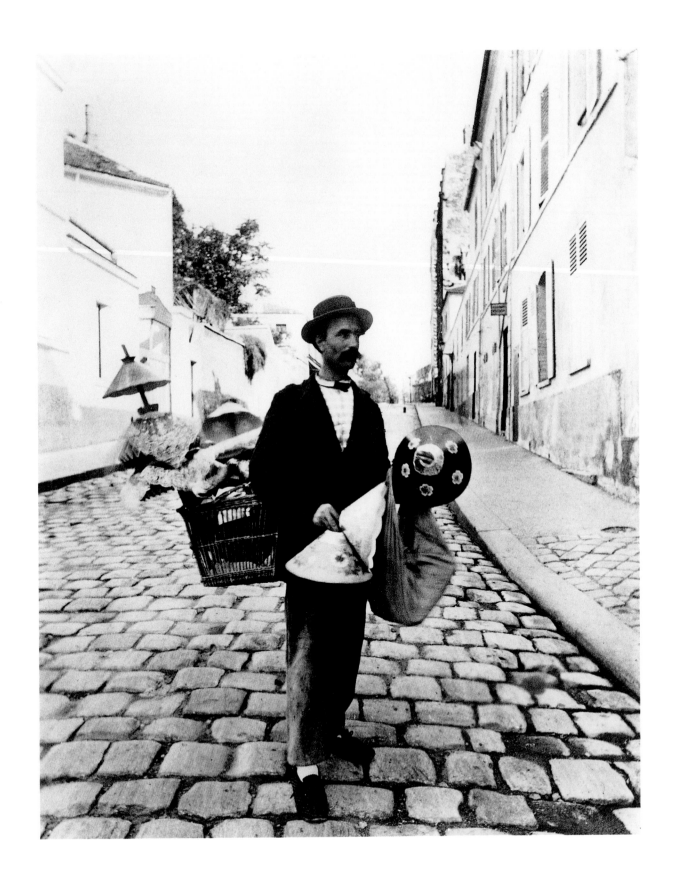

Paul Strand
American, 1890–1976

Blind Woman, New York, 1916
Gelatin-silver print by Paul Strand and Richard Benson (1975)
33 x 25 cm

The portrait conveys endurance, isolation, the curious alertness of the blind or nearly blind, and an unexpected beauty in the strong, possibly Slavic, head. Our understanding of the portrait is informed by the stark sign that hangs from the sitter's neck and by the New York City Licensed Peddler's badge pinned at the top of her coat. The whole concept of blindness is aimed like a weapon at those whose privilege of sight permits them to experience the picture, much like the 'dramatic irony' in which an all-knowing audience observes a protagonist on stage.

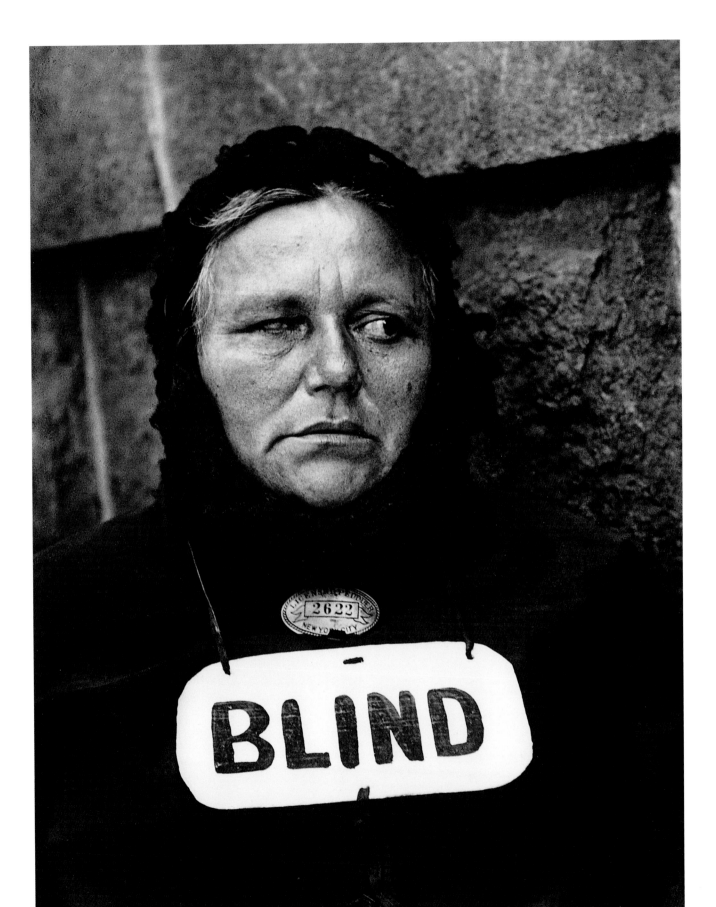

August Sander
German, 1876–1964

Der Handwerkmeister (Pastry chef) Franz Bremer, Cologne, 1929
Gelatin-silver print (1970s)
30 x 22 cm

Sander published *Antlitz der Zeit* (*Face of Our Time*), a book of 60 portrait photographs, in 1929. It was a preview of his larger series, *People of the Twentieth Century*. This was envisaged as a typological survey of a whole society. In 1936 the Nazis destroyed all remaining copies of Sander's first book, and the complete series was not published in his lifetime. 'It is not just a person's face that characterizes him, but also the way he moves,' Sander wrote in the early 1930s. He thought of the photographer's task as to attempt to stabilize and capture that characteristic movement in still photographs. Sander's most successful portraits show how an individual presents himself in front of the camera, what pose he adopts and what attributes he uses to speak for him.

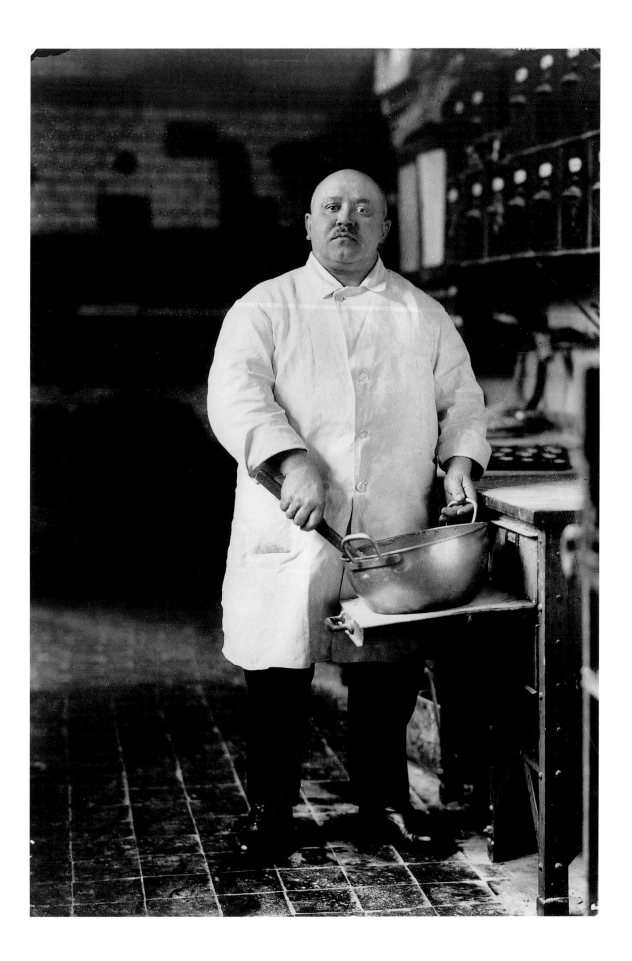

El Lissitzky
Russian, 1890–1941

The Constructor, 1924
Gelatin-silver print
11 x 12 cm

El Lissitzky presents himself as a designer with the attributes of his profession – graph paper; a hand holding a pair of compasses; and typographical elements of his own letterhead. The montage was made by contact printing the different negative elements one after the other on the same positive printing-out paper. This changed colour during the exposure, which enabled El Lissitzky to control the process. This print is probably a contemporary copy made for reproduction: it belonged to Mikhail Larionov. El Lissitzky represents himself as a modern hero – a designer not only of objects but of society.

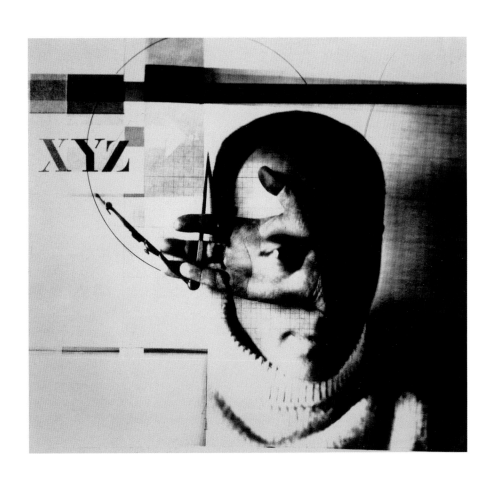

Manuel Alvarez Bravo
Mexican, 1902–2002

La buena fama durmiendo (Good reputation sleeping), 1939
Gelatin-silver print (1975)
17.3 x 24.2 cm

This was made at the request of André Breton for the cover of the catalogue of the International Surrealist Exhibition held in Mexico in 1940. Bravo received the commission by telephone, conceived the image immediately, organized the model and props and made the photograph at noon the same day. Although the image could not be used on the catalogue (because of the pubic hair), it remains among Bravo's most celebrated and intriguing photographs.

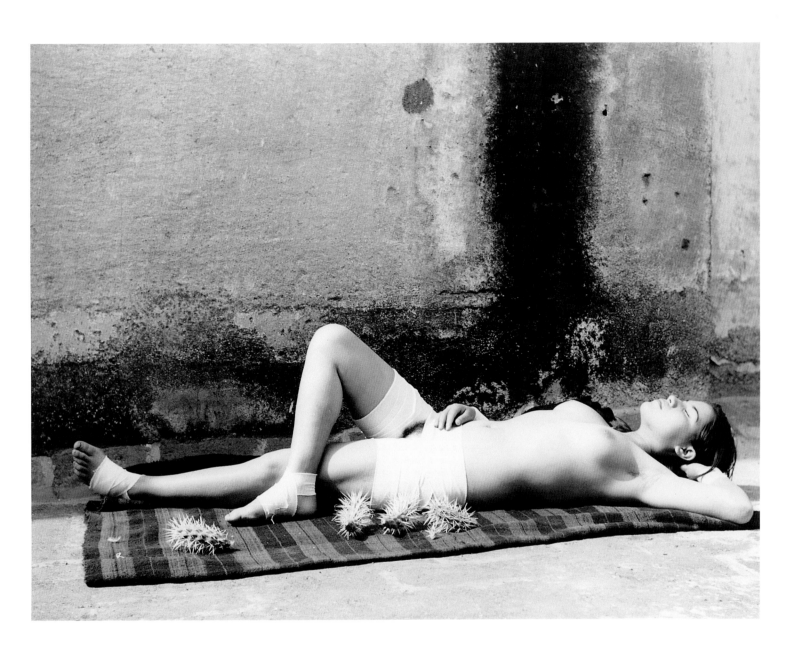

Edward Weston
American, 1886–1958

Civilian Defense, 1942
Gelatin-silver print by Cole Weston (1980)
19 x 24 cm

Weston began a new series of works in 1942. Following the Japanese bombing of Pearl Harbor, Weston became an air-raid warden at Point Lobos, formerly his favourite photographic site. Californians were equipped with gas-masks in preparation for enemy attack. This tableau, sometimes called *Victory*, shows Weston's wife Charis nude on a couch wearing a gas-mask and accompanied by the palm of peace: the classic artistic subject of the nude compromised by wartime necessity and rhetoric. He wrote of this as 'one of the great photographs on which I will stake my reputation'.

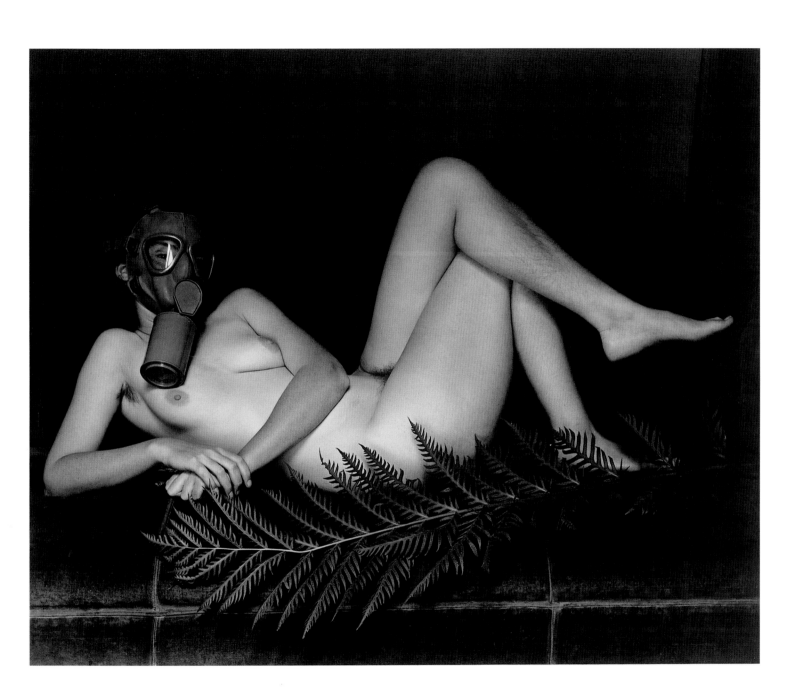

Robert Doisneau
French, 1912–94

Les Mains de Picasso, Vallauris, France, 1952
Gelatin-silver print (1980)
30 x 24.5 cm

This portrait of Picasso is typical of the style Doisneau evolved by the late 1940s, inviting his subject to play out a surreal fantasy. Arriving early for a photo-shoot at the artist's château at Vallauris, he found Picasso at lunch with Françoise Gilot. The bread they were eating took his attention: 'Look at these,' said his host, 'because they have four fingers our baker calls them Picassos!' As Doisneau later recalled, 'Because he was in such good spirits I dared to place a roll either side of his plate. He did exactly as I wanted, sticking his arms underneath the table as if the rolls were their extensions!'

Peter Hamilton, The Open University, UK

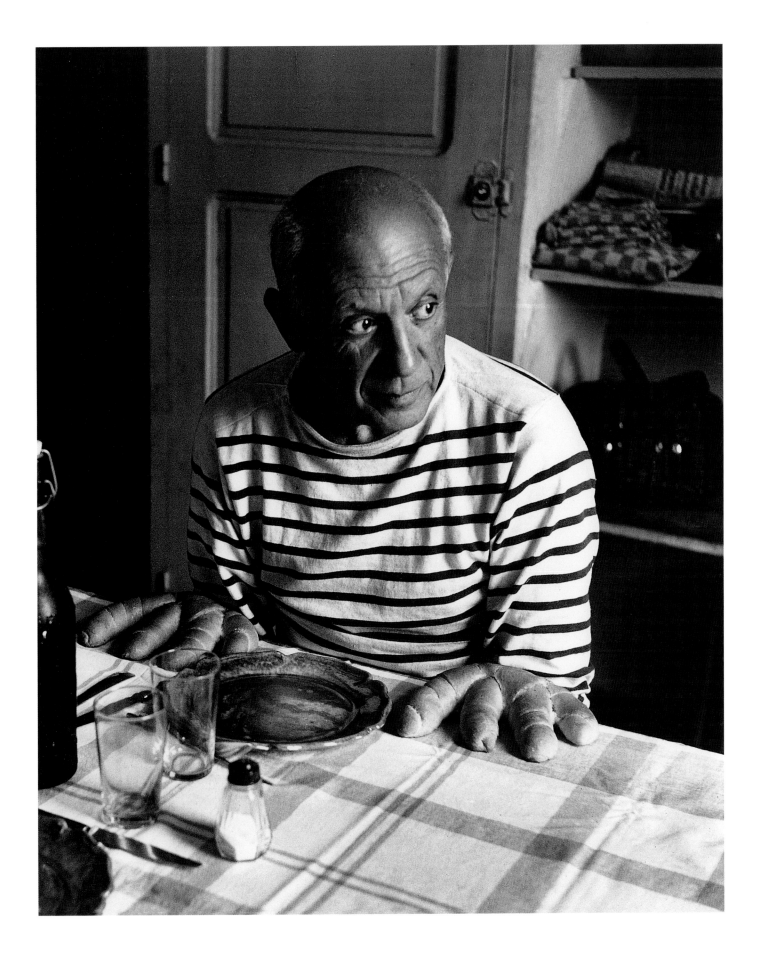

Seydou Keita

Malian, 1923–2001

Untitled (Young man with a flower), 1959
Gelatin-silver print (2001)
50.5 x 38.5 cm
signed and dated

Given by Hackelbury Gallery, London

European clothes became more fashionable among Mali's city-dwellers in the 1950s than the traditional *boubou* (a kind of cloak). Few people could afford to dress expensively, so Keita kept a wardrobe. At the studio customers could choose from three different European suits with a tie, shirt, shoes, hat. There were also other accessories, such as the fountain pen, plastic flower and silk handkerchief seen here, but also a radio set and a telephone. The flower could refer to 'Fleur de Paris', a popular song that begins: 'C'est une fleur de Paris / Du vieux Paris qui sourit ...' ('It is a flower of Paris / Of the old Paris that smiles ...').

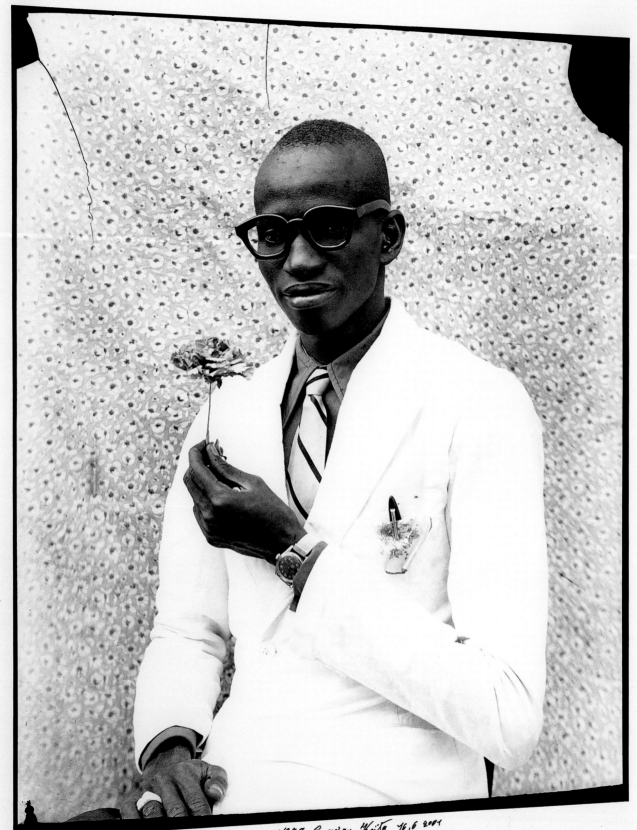

4959 Seydou Keïta 16.6 2001

Diane Arbus
American, 1923–71

Boy with a straw hat waiting to march in a pro-war parade,
NYC, 1967
Gelatin-silver print from *Diane Arbus: Ten Photographs*,
printed by Neil Selkirk
37.5 x 37.5 cm

The boy announces his patriotism through various kinds of objects, the most strident being badges urging the bombing of Hanoi (capital of North Vietnam) and support for 'our boys in Vietnam'. He wears the Stars and Stripes and confronts the counter-culture opposed to the Vietnam War by observing the conservative dress code of a dark, three-piece suit and a bow-tie. His straw boater counterpoints his fierce message and prominent ears. The boy has made his position perfectly clear, as has the photographer.

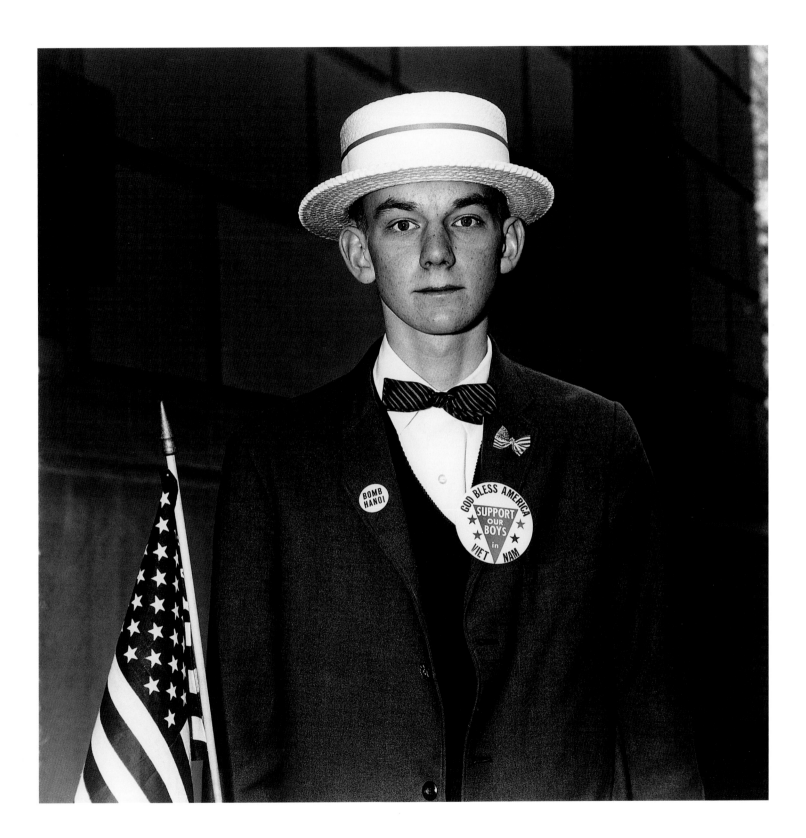

Richard Avedon
American, born 1923

Marlene Dietrich, turban by Dior, The Ritz, Paris, August 1955
Gelatin-silver print
46 x 36.5 cm

After revitalizing and redefining fashion photography in the late Forties, Avedon photographed one of the icons of modern cinema in 1955. Marlene Dietrich wrote of her face as an object, created by Joseph von Sternberg and a specific use of light: 'The key light, directly behind the camera, is the most important of all. The higher this key light is placed, the longer and narrower the face will appear on the screen. If an actress happens to be blessed with high cheekbones, such lighting sketches attractive, soft shadows on both cheeks.' Avedon, one of Dietrich's favourite photographers, seems to be following these light directions. The mystery of the mask is enhanced by cigarette smoke and a Dior turban.

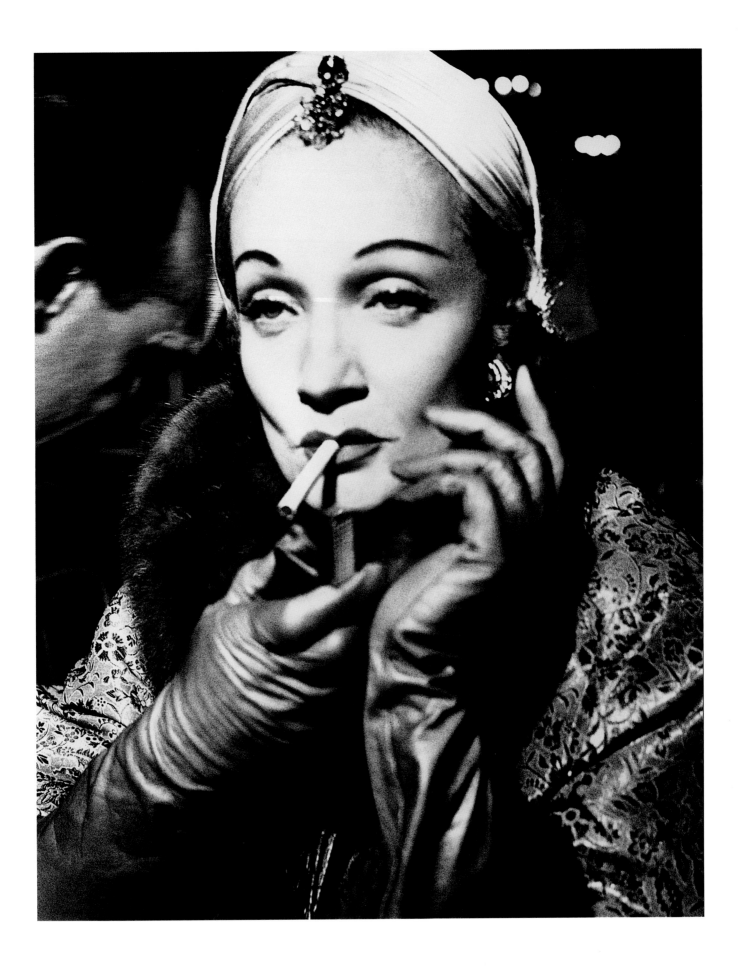

Michael Ward
British, born 1929

Fats Domino at the Albert Hall, 1990
Gelatin-silver print
22 x 32 cm

Given by the artist, 1991

Security was very tight. We, the photographers, were only allowed in after intense scrutiny of our passes. We were given ten minutes. The concert had already started and we were only allowed to take photographs sitting or lying down in one of the aisles. The only thing that was helpful was that there was plenty of light. I lay on my stomach, elbows painfully on the floor trying to get a close-up of the extraordinary silver ring and cuff-links Domino was wearing, and include a recognizable part of his face in the picture. After several neck-breaking efforts – I managed to get this shot.

Michael Ward

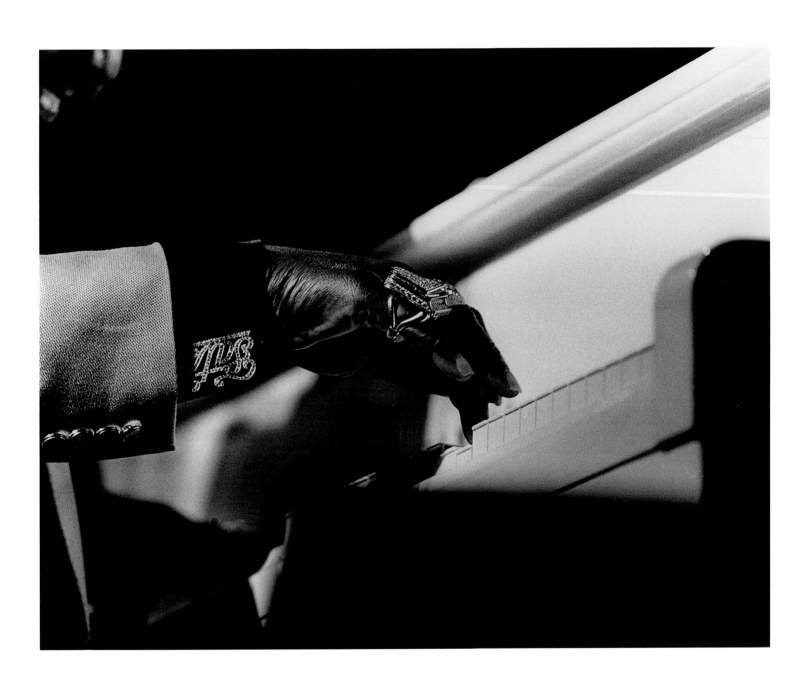

David Goldblatt
South African, born 1930

Boss Boy, Battery Reef, Randfontein Estates Gold Mine, 1966
Gelatin-silver print
24 x 19.3 cm

Given by the artist, 1992

Early in his photographic career David Goldblatt realized that he was unsuited to the brilliant 'decisive moment' art of such heroes as Cartier-Bresson. He concentrated on a more static, deliberate approach to the condition of his native South Africa. He made a special study of the gold mines in the 1960s. The 200,000–300,000 black miners were confined by law to the least skilled types of work. Within teams, however, a strict hierarchy prevailed, with commensurate pay and prestige. The 'Boss Boy' rank is displayed in many ways: with the REGM insignia on an arm, a clinometer (for underground measurements) in a pocket, a notebook, pens and pipe. The Boss Boy's wrists bear a plastic identity band, plus copper and rubber bands. He has a pocket-knife in a home-made sheath on his belt. The Zobo watch was a reward for accident-free work.

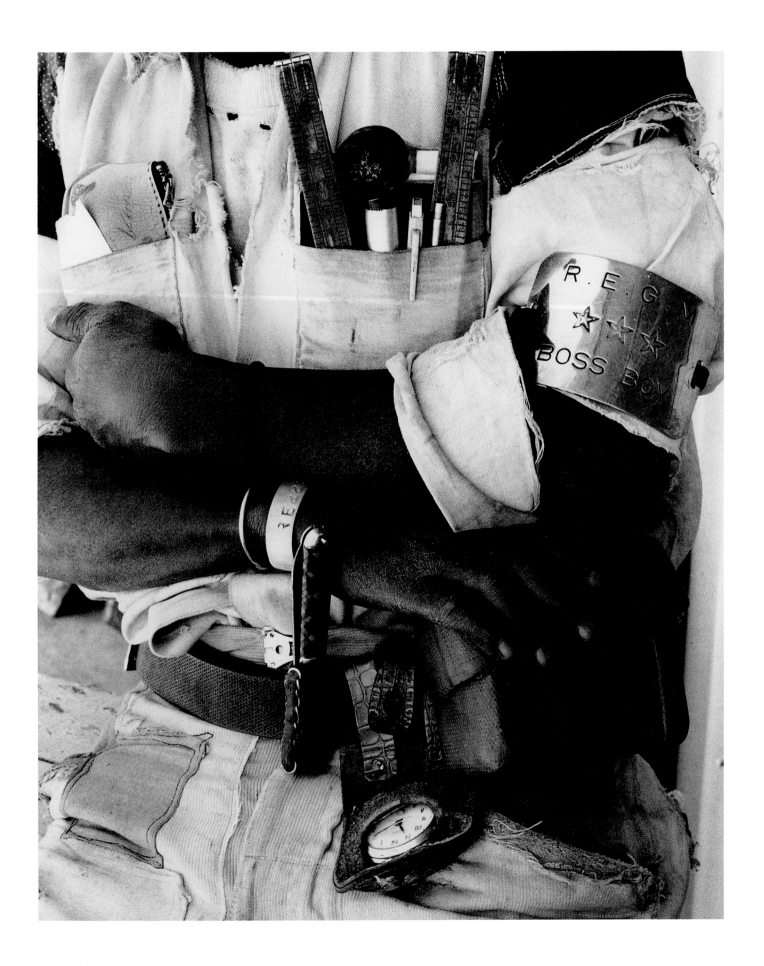

Brian Griffin
British, born 1948

Carpenter, from the series *Work at Broadgate*, 1985–86
Gelatin-silver print
35.6 x 35.6 cm

Given by the artist, 1988

The series was commissioned by Davenport Associates, a design consultancy that worked closely with Rosehaugh Stanhope, the developers of Broadgate. In homage to the tradesmen who worked on the site, Griffin posed them with their tools in the manner of crusader knights.

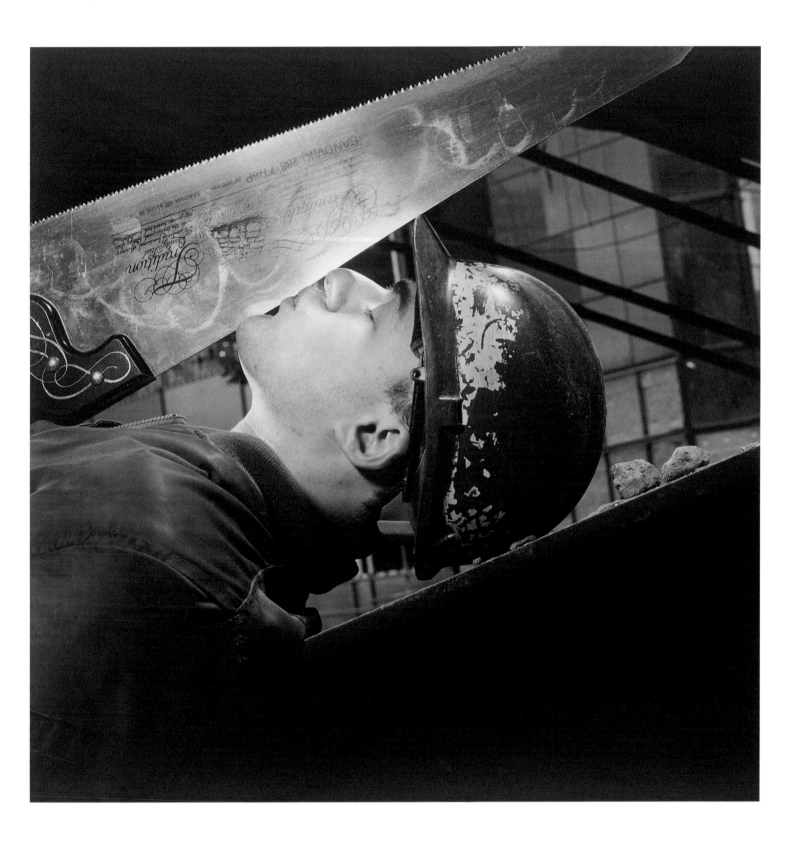

Tessa Traeger
British, born 1938

Languedoc, 1995
Gelatin-silver print
50 x 39.5 cm

Given by the artist, 1997

I have been documenting these farmers, living high up in the mountains, for many years, recording their age-old customs and skills and their natural way of life. M. Joseph Bourrey grows thatching straw to make these 'Gerbes de Mariages'. After a wedding the sheaf of straw is laid upon the ground and set alight and the young couple then leap over the flames. It is probably a pre-Christian ritual that is sometimes adhered to in the Ardèche, a region where you can still see houses with a cross at one end of the roof and a stone ball at the other end to ward off evil spirits.

Tessa Traeger

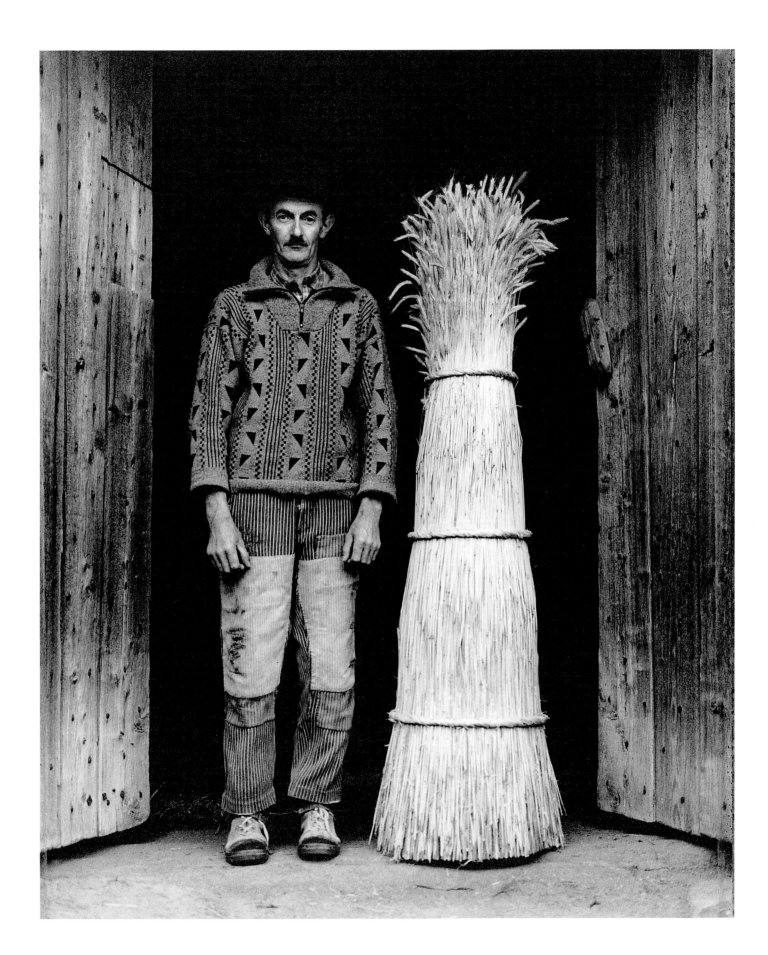

Michael Bennett
British, born 1954

Uncle Cyril arriving for tea, 1975
Toned composite gelatin-silver print (1978)
Diameter: 8.3 cm

This portrait was made for a series of 36 by Bennett entitled *The Family*. The exhibition toured widely and was featured on BBC TV's *Arena* in 1977. Bennett has subsequently worked as a photomontage artist, aiming 'to arrive at a satirical or humorous end which is mass-published'. His work featured in *The Satiric Verses* (*Private Eye*, 1989).

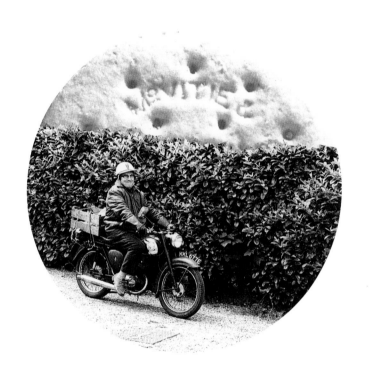

Lewis Morley
Australian, born 1925

Christine Keeler, 1963
Gelatin-silver print
61 x 51 cm

Given by members of the Knaus family, through the
American Friends of the Victoria and Albert Museum, Inc., 1999

following pages

Christine Keeler: the enlarged contact print, 1963
Gelatin-silver print (2001)
61 x 51 cm

Pledged gift of David Knaus, lent by the
American Friends of the Victoria and Albert Museum, Inc., 2002

The photograph was taken at the height of the revelations regarding the exposure of the War Minister and a young female, caught up in 'The Profumo Affair'. It was one of a series of publicity shots for an intended film, which never saw the light of day. During the session, three rolls of 120 film were shot. The first two rolls had Christine sitting in various positions on the chair and on the floor, dressed in a small leather jerkin. It was at this point that the film producers who were in attendance demanded she strip for some nude photos. Christine was reluctant to do so, but the producers insisted, saying that it was written in her contract. The situation became rather tense and reached an impasse. I suggested that everyone, including my assistant, leave the studio. I turned my back to Christine, telling her to disrobe, sit back-to-front on the chair. She was now nude, fulfilling the conditions of the contract, but was at the same time hidden.

We repeated some of the poses used on the previous two rolls of film. I rapidly exposed some fresh positions, some angled from the side and a few slightly looking down. I felt that I had shot enough and took a couple of paces back. Looking up, I saw what appeared to be a perfect positioning. I released the shutter one more time – in fact, it was the last exposure on the roll of film. Looking at the contact sheet, one can see that this image is smaller than the rest because I had stepped back. It was this pose that became the first published and most used image. The nude session had taken less than five minutes to complete. It wasn't until I developed the film that I discovered that somehow I had misfired one shot and there were only 11 images on a 12-exposure film.

Lewis Morley

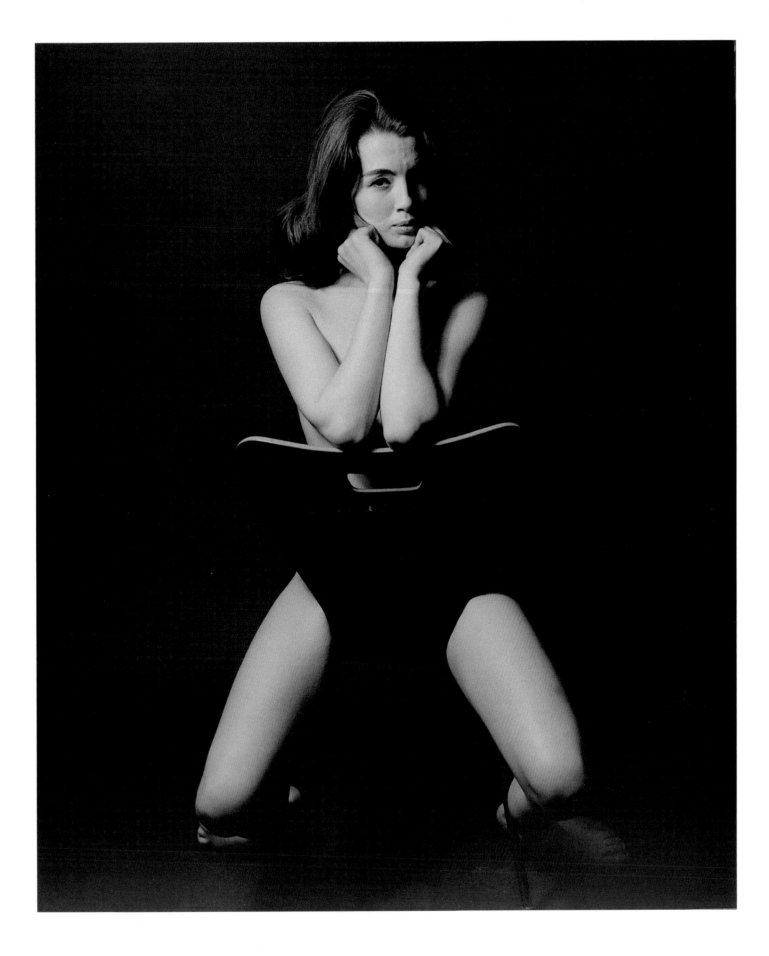

CHRISTINE KEELER '63

A/P

Lewis Morley
Australian, born 1925

Dame Edna Everage
Gelatin-silver print (2001)
47 x 30 cm

I've always known how to sit modestly in a chair, which is more than you can say for my colleague Sharon Stone. There is only one photographer on the planet who could have persuaded me to take off my clothes and assume this slightly uncalled-for position, and that is Lewis Morley. Incidentally, I practically adopted him when he was a poor little Chinese war orphan by the name of Lu Mor Lee. Christine Keeler was a bit before my time, I'm afraid, but Lewis asked me to sit on the same chair and the result is this raunchy snap. Without denigrating little Christine, I think I bring a spooky dignity to this otherwise unacceptable pose. My bosom was never my strongest point and I always thought that, except as a rendezvous for thirsty babies, it was a pretty overrated part of the female anatomy, but my legs have always been my best and most envied feature (apart from my mind) and this portrait really shows them off, don't you think, Possums? Eat your heart out, Tina Turner!

Dame Edna Everage

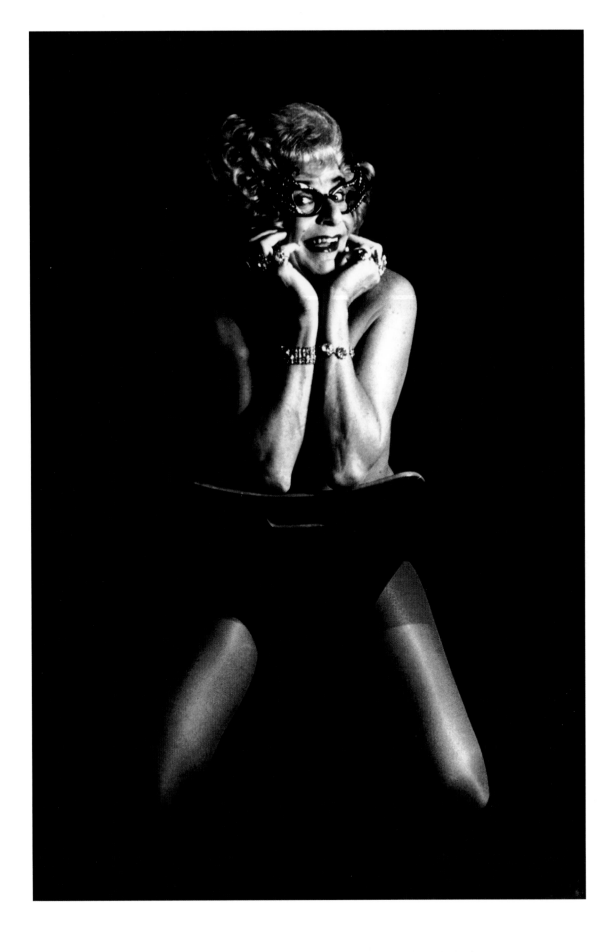

Anonymous

Chair, bent plywood, steel frame
Designed in the manner of Arne Jacobsen
Manufacturer unknown, *c*.1960
Back of seat stamped: Made in Denmark
Inscribed in pen under the seat with names of sitters
and donation details.
H 80 cm, W 45.5 cm, D 46 cm

Pledged gift of Lewis Morley and Dr John and Mrs Laura Knaus,
lent by the American Friends of the Victoria and Albert Museum, Inc., 2002

This chair was designed in imitation of Arne Jacobsen's model 3107 chair, in continuous production by Fritz Hansen of Denmark since 1957. Jacobsen's chair, the most commercially successful of several related designs, exploits the structural property of a thin sheet of plywood, cinched at the centre and bent to form a continuous back and seat. The splayed metal legs allow the chairs to be stacked. The sensuous shape of the plywood form suggests the curve of the human body. Jacobsen's design inspired numerous lookalike chairs, and continues to do so. This example must be one of the earliest examples, since we know it was purchased in London, possibly in a Heal's sale for five shillings, in or before 1962, just five or so years on from the launch of the original chair. In comparison with Jacobsen's chair, this is crudely executed with poor proportions. The plywood is much thicker and less subtly moulded. The cinched 'waist' of the chair is more pronounced, and the front of the seat is set too far back. Unlike Jacobsen's chair, this model has a cut-out handle at the top of the seat, but even this is inaccurately positioned and irregularly cut. The fixing joint of the metal legs under the seat is less sophisticated, and has failed.

Gareth Williams, Department of Furniture, Textiles and Dress, V&A

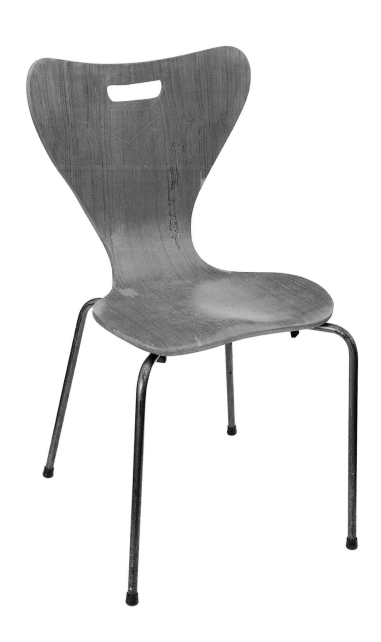

6

Not content with bringing objects to their studios, or capturing them as found – or 'given' – in street or home, photographers also create objects that either exist only to be photographed or may exist only inside a camera. Here photography connects with science, sculpture, painting and cinema. Giles Revell uses a combination of recent technologies embracing photography, the electron microscope, new digital software and state-of-the-art inkjet printing. Revell interprets a microscopic whirlygig beetle at heroic size, and in such intimate detail that we can see the insect's battle scars. Other artists here create playful alternative landscapes, like Sian Bonnell with *Putting Hills in Holland*. James Casebere, Calum Colvin and Mari Mahr create places mixing fantasy, memory and desire. Meanwhile, the artist Oliver Boberg creates illusionistic models of reality, which – however skilled we may think we are in separating truth from fiction – put that reality in quotation marks and force us to blink in disbelief. Finally, Neil Reddy finds virtual visions inside the camera. His extraordinary tour de force suggests new vistas for exploration.

Making Things

Sian Bonnell
British, born 1956

Putting Hills in Holland, 2001
C-type colour print
46.5 x 60.5 cm

Purchased from the Sir Cecil Beaton Fund, 2001

Moulds resemble hills; this was the starting point for a series which dis-locates manufactured and natural forms. The colour and placement are intentionally seductive, alluding to the excess and decay in Dutch genre painting. Despite the order and control of the de Stijl movement, there is something about Holland that makes one want to misbehave. The chocolate cake was bought fresh locally, but the custard tart came from England and was past the sell-by date. This picture might be regarded as a confection – but with a bitter taste…

Sian Bonnell

Calum Colvin
British, born 1961

Untitled, 1985
C-type colour print
79 x 100 cm

Calum Colvin was trained at the Royal College of Art, but he is part of the resurgence in Scottish art in the 1980s. Initially, Colvin experimented with sculptures that included photographs. He felt he had reached a dead end until he encountered works by the photographer Les Krims, a creator of elaborate skits on American mass-culture, and by the French painter/photographer Georges Rousse, whose abstract paintings in large spaces are transformed into startling illusionism when photographed. 'I decided,' Colvin recalls, 'that I should be putting the sculptures into photographs – not the other way round.' He found ways not only to assemble objects and apply paint, but also to photograph the result to create a rowdy new *trompe l'oeil*.

James Casebere
American, born 1953

Golden Apple, 1986
Gelatin-silver transparency on light-box
74.5 x 100 cm

Casebere is a characteristic postmodernist in that his works exist at a remove. Most of his time is spent building table-sized sets or models, which no one will see. He then photographs the model and presents it in photographic form – here as a backlit image in a light-box. He is also postmodern in addressing stereotypical imagery and nostalgia. The Golden Apple – actually drained of colour, a cool blank for our projections – is larger than life, as if it has already been imagined or dreamt. It opens, like the window beside it, onto a hundred fairy tales.

Mari Mahr
British, born in Chile, 1941

A few days in Geneva, 1985
Gelatin-silver prints (two frames from a series of ten)
Each image 50.5 x 75 cm

Mari Mahr was born in Santiago, Chile, was brought up in Budapest, where she worked as a photojournalist, and then settled in London. She had become dissatisfied with documentary, finding it misleading, so she began a new photographic career, making tableaux based on the lives of Georgia O'Keeffe and Lili Brik. Another series was set in ancient China. This one is based on a visit to Geneva to see friends. Mahr took photographs from the cathedral tower and later acquired sheet-music of a melody that kept coming into her mind during the visit – Chopin's *La Grande Polonaise Brillante*. With these ingredients and her characteristically light touch, Mahr transformed a few objects in a corner of her studio into a few days elsewhere.

Oliver Boberg
German, born 1965

Anliegerweg (Resident Path), 2000
C-type colour print
70 x 44.5 cm

Given by BMW Financial Services, 2001

Boberg makes images of typical urban realities, reminiscent of locations favoured by many contemporary photographers around the world. However, he creates them in an unusual way. First he pursues such motifs with a camera, then he makes models in his studio. These are carefully sculpted, using a variety of props, and painted. The finished model is then photographed. 'I try to keep my motifs free of everything that is individual about a certain place,' Boberg has stated, 'and to present a place in a general way so that anyone can imagine it for themselves.'

Giles Revell
British, born 1965

Whirlygig beetle, 2001
Inkjet print
182.5 x 106 cm

Giles Revell uses the latest advances in photography, computer technology and printing. The image is rendered from a gold-dusted cast of the insect using a Scanning Electron Microscope (SEM). 400–500 digital scans of the specimen are then 'sewn' together using new software. Revell then reconfigures the image into a true-to-life form, modelling it with a virtual light-source. He then works with printers to enlarge the image to a dramatic scale without losing the subtlety of the original, which has a diameter of up to 4 mm. The whirlygig beetle is especially complex as it has two sets of limbs, allowing it to swim and to fly.

Neil Reddy
British, born 1963

Three Feet to Infinity, No. 7, 1995
Gelatin-silver print
58 x 45 cm

Given by the artist, 1996

I decided to work directly with light, rather than its reflection, and to manipulate it by using the optics and mechanics of the camera. During long exposures, pin-holes of light are drawn in and out of focus to record an image that is the record of an event invisible to the human eye. This occurs within the darkened chamber of the camera itself and has no physical existence except in its photographic trace. In this sense any notion of the photograph being an objective record becomes meaningless as the subject and its image become inextricably fused together.

Neil Reddy

Acknowledgements

This book is based on *Seeing Things: Photographing Objects 1850–2001*, an exhibition held in the Canon Photography Gallery at the Victoria and Albert Museum (21 February–18 August 2002). The V&A, through V&A Publications, is delighted to have been able to work in partnership with the publisher Jonathan Cape, to recast and revise the exhibition in book form to give wider circulation to the photographs. Our thanks go, firstly, to the artists themselves for generously allowing us to illustrate their work and also, in many instances, to publish the illuminating captions they wrote especially for the exhibition. Other captions were written by a number of specialists from inside and outside the V&A and we thank them all for their generous contributions to the project. Unless otherwise stated, all the other captions were written by myself and my colleagues in the V&A's Photography Collection: Charlotte Cotton and Martin Barnes, the Curators of Photographs; Kate Best, Assistant Curator of Photographs; Wiebeke Leister, Regine Schallert and Chloe Wardle, interns. Valuable advice was provided by many other V&A colleagues, including Tony North (metalwork), Reino Liefkes (glass), Terry Bloxham (ceramics) and Gareth Williams (furniture). For technical evaluation of problematic photographs, I am indebted to James Stevenson, head of the V&A's photographic studio, and to the late Elizabeth Martin, formerly Senior Conservator of Photographs.

We are grateful to the many copyright holders who have kindly allowed us to reproduce works here. Unless otherwise stated, all works are the copyright either of the photographers or their Estates, or of the Board of Trustees of the Victoria and Albert Museum. In addition we record the following copyrights:

Hardware store, New York, 1938 by Berenice Abbott is ©Berenice Abbott/Commerce Graphics Ltd. Marlene Dietrich, The Ritz, Paris, 1955 by Richard Avedon is ©1955 by Richard Avedon. Les Mains de Picasso, Vallauris, France, 1952 by Robert Doisneau is published by courtesy of Agence Rapho, Paris. Untitled (Young man with a flower), 1959 by Seydou Keïta is ©Seydou Keïta and published by courtesy of HackelBury Gallery, London. Chez Mondrian, 1926 and Homing Ship, 1944 by André Kertész are ©Ministère de la Culture, Paris. The Constructor, 1924 by El Lissitzky and Bedroom in a villa in Cologne-Marienburg, Germany, 1927 by Werner Mantz are ©DACS 2004. Salad Ingredients, 1947 by Irving Penn is copyright ©1947 (renewed 1975) Condé Nast Publications, Inc. Lingerie, Lumière and Salle à Manger, all from Eléctricité, 1931 by Man Ray, are ©Ray Trust/ADGP, Paris and DACS, London 2004. Der Handwerkmeister (Pastry Chef), 1929 by August Sander is ©Die Photografische Sammlung/SK Stiftung Kultur – August Sander Archiv, Köln/DACS 2004. Chicago, No.21, 1949 by Aaron Siskind is ©The Aaron Siskind Foundation and reproduced by courtesy of the Robert Mann Gallery, New York. Cottage Interior, Lightmoor, Shropshire, 1953 by Edwin Smith is reproduced by kind permission of the Royal Institute of British Architects Library, Photographs Collection. Blind Woman, New York, 1916 and Iris, Georgetown, Maine, 1928 by Paul Strand are respectively ©1971 and ©1950 Aperture Foundation Inc., Paul Strand Archive. Excusado, Mexico, 1926, Nautilus Shell, 1927 and Civilian Defense, 1942, photographs by Edward Weston, are ©1981 Center for Creative Photography, Arizona Board of Regents. Despite our best efforts we have been unable to trace the copyright holders of the work of the Worsinger/Verne Williams studio.

We are most grateful to Marina Warner, a long-standing friend of the V&A Photography Collection, for taking time out of a very busy schedule to write her valuable introduction to this book. We at the V&A are deeply indebted to Mark Holborn and his colleagues at Jonathan Cape for the enthusiasm and expertise they have brought to this co-publication with the Museum. I am especially grateful to Mark Holborn and Mary Butler, head of V&A Publications, for producing such an extraordinary finale to my career as a curator at the V&A – beginning as Assistant Keeper of Circulation (travelling exhibitions) in December 1970, becoming Assistant Keeper in charge of the Photography Collection in 1977, and finishing, as Senior Curator of Photographs, in August 2004.

Mark Haworth-Booth
January 2004

Published by Jonathan Cape 2004

2 4 6 8 10 9 7 5 3 1

First published in Great Britain in 2004 by
Jonathan Cape
Random House, 20 Vauxhall Bridge Road,
London SW1V 2SA
in association with the Victoria and Albert Museum

The Random House Group Limited Reg. No 954009
www.randomhouse.co.uk

A CIP catalogue record for this book is available from the British Library

ISBN 0 224 07289 7

Printed and bound in China by C&C Offset Printing Co.,Ltd

Edited by Mark Holborn
Design by Friederike Huber and Mark Holborn